Midsummer

Also by Maryann D'Agincourt

Journal of Eva Morello

All Most

Glimpses of Gauguin

Printz

Shade and Light

Marriage of the Smila-Hoffmans

MIDSUMMER

Maryann D'Agincourt

PP
Portmay Press

New York

Cover image: *Sunlit Wall Under a Tree*, c. 1913, John Singer Sargent

Cover design by Emily Albarillo

Printed in the United States of America

ISBN 978-1-959986-28-7 (paperback)
ISBN 978-1-959986-30-0 (hardcover)
ISBN 978-1-959986-29-4 (ebook)

Library of Congress Control Number: 2024911868

Publisher's Cataloging-in-Publication
(Provided by Cassidy Cataloguing Services, Inc.)
 Names: D'Agincourt, Maryann, author.
 Title: Midsummer / Maryann D'Agincourt.
 Description: New York : Portmay Press, [2024]
 Identifiers: SBN: 978-1-959986-28-7 (paperback) | 978-1-959986-30-0 (hardcover)| 978-1-959986-29-4 (eBook)
 Subjects: LCSH: Married people--Travel--France--Antibes--Fiction. | Hotels--Scotland--Edinburgh-- Fiction. | Chance--Fiction. | Disappeared persons--Fiction. | Uncertainty--Fiction. | BISAC: FICTION / Literary.
 Classification: LCC: PS3604.A332544 M54 2024 | DDC: 813/.6--dc23

PP

Portmay Press
244 Madison Avenue
New York, NY 10016
www.portmaypress.com

With deep gratitude to Emily Albarillo, the editor of this novel—her sensitivity to language and acumen are unparalleled

For Joan and Peter

Are you sure

That we are awake? It seems to me

That yet we sleep, we dream.

—William Shakespeare, *A Midsummer Night's Dream*

In that latitude the midsummer days were long, midsummer nights only a short darkness between the long twilight that postponed the stars and the green dawn clarity that sponged them up.

—Wallace Stegner, *Angle of Repose*

Two Couples

The Present

1

There are four of them, two couples in their early thirties, who, upon meeting, will believe the other pair are strangers. The following week, an incident will occur: Lia, the oldest by a month, the smallest, and perhaps the finest will absorb it with hope; Sam, her husband, with ambivalence; Ned, with angst; and Raine, who may or may not be the most contradictory of the four, with affliction.

* * *

A June morning, at a high latitude, on the longest day of the year: with suitcases in hand, Sam and Lia, the heat deepening their fatigue, descend a stone stairway. After walking fifty feet in a southeast direction, they emerge from a flood of sunlight and enter the lobby of a boutique hotel close to the center of Edinburgh.

The baseball cap atop Sam's head is tight across his forehead; tufts of dark blond hair nestle behind his ears. The confidence he exudes, neither warm nor off-putting, is encouraging for those looking for reassurance. Lia is slight, her eyes deep-set, gray with tiny dark streaks. Her overall demeanor reflects how steady she is, yet her step is nearly a forward skip. Not having slept on the overnight flight, she both fights and accepts how drowsy she is; she lowers her luggage onto the black-and-white tiled floor. Above, two ceiling fans whir at a rapid pace. A few feet away, Sam leans over the small reception desk. Shadows cross her husband's back, enlarge his form; for a moment he is no longer Sam, his intelligence extinguished. Lia purses her lips.

The hotel clerk's words float toward her: he advises Sam to leave the suitcases in the nearby closet and first go to breakfast—it's the room on the left. Sam turns to Lia, his gaze meets hers; he is again the person she married. Lia's intention is to say no, she needs to sleep, though her curiosity has been aroused by the sound of lively voices wafting in from the breakfast area. She nods.

Dark-wooded wainscoting borders pale blue wallpaper in the crowded area where the early meal is served. All the tables have been taken. Sam thrusts his hands inside his pants pockets; he surveys the room. At the back he spots two empty seats covered in sunlight; at the other end of the table, another couple, cloaked in shadows, is conversing intently. Sam approaches; he grins as if about to speak. Having drawn their attention, he

pauses; with an expression of humility, he lowers his eyes and asks if he and his wife may sit at the table. The man, a touch of soulfulness in his eyes, nods. The woman, dark-haired, an olive complexion and pale green eyes, appraises the couple; her gaze encouraging, she motions for Sam and Lia to sit in the unoccupied chairs.

Sam and Lia each pick up a menu from the table and with heavy eyes review it. The other two draw their chairs closer to the table, resume their private conversation. Lia takes a sidelong glance at the couple, assesses they are approximately the same age as she and Sam; the woman is above average height and has a medium build, in contrast to her elfin face. The man is lightly tanned, with broad cheekbones, lanky, an inch or two taller than Sam. From her initial observation of the couple, Lia is hopeful, then disappointed; she attributes the letdown to how tired she feels.

Once the waiter has jotted down Sam and Lia's order, the man catches Sam's gaze and asks, "You're Americans, aren't you?" He speaks in an unaffected tone of camaraderie. He and the woman he is with say they have not noticed any other tourists from the United States at the hotel and appear embarrassed to acknowledge this; they do not like to view themselves or anyone else as coming from a particular country, Lia surmises.

"Yes, yes we are," Sam acknowledges. He gets up from his seat, reaches across the table, and shakes the man's hand. They each say their name: Sam sounds affirmative, Lia earnest, Raine brisk, and Ned neutral.

Ned, to his surprise, is relieved they are Americans and, though he and Raine have traveled extensively—it is their hobby—they have not before experienced the same sense of isolation; it is something unknown to them, difficult to comprehend. For on this trip those they've encountered are different from other fellow travelers they've met in the past—less expressive, nearly anti-social. This has baffled the couple; they've always connected with strangers or people from other countries, no matter where they have been, no matter how far from home they've journeyed.

Ned's lips part; he studies Sam and Lia. Raine's attention remains on her husband. She wonders if Ned will expect too much from them because they are Americans—she knows he takes people much too seriously. She has concluded for a while now that national origin is inconsequential in terms of whom she and her husband connect with. Yet to her dismay she is also pleased that Sam and Lia are Americans. She wonders if she and Ned appear more like tourists rather than experienced travelers.

Discarding such thoughts, Raine turns her gaze to Sam and Lia, and smiles. Her voice gravelly, she says, "Let me guess where you are from—not from the same place, I think. Lia, you are from the South and Sam, you are a midwesterner."

Sam's tone is more refined than his appearance. "Fifty percent correct—yes, Lia is from Richmond. I'm from Boston."

Her expression alert, Raine brushes aside her glossy chin-length hair and says, "Ned too is a Bostonian. We have an apartment in Cambridge. I was born in San Francisco, lived there until I was six, went to college in New York, and worked in the

city for a few years." Raine, aware of how Sam and Lia closely listen to her, thinks they appear mismatched as a couple. Lia is under average height, fine features, a pale complexion, and Sam, ruddy, with a piercing gaze and a pronounced masculinity that mildly offends Raine.

All are disappointed that they live in the same city. Although Lia is from Virginia, like Ned and Sam, she attended college in Boston. Ned adds that his parents are Chicagoans who moved to Boston soon after they met. And Raine says that her mother left San Francisco with her three young children a few years after the death of her husband, their father.

Lia, disturbed by the sudden blank look in Raine's eyes, wonders if losing her father at a young age has become an afterthought to her. Deep within, she feels a rising anger; she doesn't know where it comes from and suppresses it.

Raine adds that her mother was originally from Massachusetts, lived in San Francisco for a good number of years, and preferred the west coast to the east coast. But at the time of her husband's passing, California seemed a significant distance from her family in Massachusetts. Raine's words are met with unease.

2

Following a few moments of silence, the conversation drifts to their work. Raine eyes Sam, asks if he is a lawyer. He smiles and looks away. Ned sits back in his seat, his gaze dispassionate; he slouches before mentioning with a flick of his hand that he is a journalist. His features are set, as if carved into his face—his eyes are almond-shaped, his facial structure broad, his lips full. Lia supposes some may find Ned attractive, while others may view his appearance as bland.

Raine lowers her head; she moves one finger in a circular pattern over the tablecloth, drawing attention to her hands, surprisingly small for her height, looks up for a moment and says that she is a commercial artist. A fleeting smile crosses Lia's lips; she tightly crosses her arms, and in a conflicted voice acknowledges that she is an elementary school teacher.

"I am not a lawyer, but in finance." Sam states, staring intently at Raine. Then he looks away. As they are abroad, they find it inappropriate to speak further about their work and are

pleased when Sam claps his hands together to indicate enough of such talk. He changes the subject to his and Lia's travels, past and present, and which cities they prefer—London, Vienna, and of course, Paris. Some of their favorite sites are Malmaison, the Freud House. Ned finds Sam's voice strong, and Sam, despite how tired he is, believes it is his duty to instill order and energy into the group.

The other hotel guests begin to leave the breakfast room, and soon the four of them are the only ones there; it is Lia who notices that all the other diners have left, and that it is raining, a sudden steady downpour. The other three are wrapped up in conversation, which has taken a turn to their imaginings of how Europe must have been in the past two centuries, more alive, more personal, warmer, and then to artists whose works they admire. Raine cries out, "Suzanne Valadon!"

"I am drawn to Picasso's paintings, his geometric shapes," Sam acknowledges. Adjusting his baseball cap, he adds, "Though I do not like how he viewed women. My grandmother was an artist," a hint of pride in his voice. "She was partial to Picasso's work."

"Degas," Ned says with ease, looking over at Raine in a way that suggests she reminds him of one of the painter's subjects.

All eyes on Lia, she pauses, then forcing herself past her fatigue she responds with a burst of passion—"Gauguin!" Another moment of silence; the other three—for different reasons—are startled by her response; Raine has concluded that Lia is too contained, Ned has ascertained she is more quiet than expressive,

and Sam is uneasy, wondering what it is about this couple that has allowed Lia to let her guard down. Lia, understanding they are surprised by her response, smiles openly.

Raine and Lia, not wanting the conversation to pause, speak suddenly; they both say Paris is their next stop.

Sam explains how he and Lia planned a weekend stay in Edinburgh to see if they like it before making a longer trip to Scotland in the future—and the plane fare to Edinburgh was significantly cheaper for some unknown reason than to Paris. But in two days they will leave for France. After Paris, they will drive through Burgundy.

Ned adds that he and Raine will be moving on, that they've been in Edinburgh for a week. They will travel to Paris this evening. Then, after five days in Paris, they will take a train to the south of France and stay in Antibes.

Because Ned and Raine appear enthusiastic about Antibes and the Riviera, Sam and Lia eye each other for different reasons; it is Lia who wonders if they should have planned to travel to the south of France instead. They have been to the Riviera only once before and their visit was brief. Also, it may be nice to be close to the water; a heat wave has been forecast.

Raine notices Lia's uncertainty and encourages them to spend more time in the south of France, explore the area, suggests that if they cannot fit it in on this trip, maybe they will do so the next time they visit Europe. In how Lia tilts her head, Raine comprehends she is not opposed to changing their itinerary. Pointedly she says that she does not want to interfere with

their plans and although she has been to Burgundy only once, she found it quite pleasant, and enjoyed the wines, and that the vineyards in the area are probably the best in the world. She avoids looking at Ned; she imagines he does not feel as strongly as she does about Sam and Lia accompanying them. He's told her he does not like the way she latches on to people when they travel because once she invites others to join them, soon afterward she regrets she has done so and is less friendly when they meet again.

After a two-hour conversation, Ned and Raine suddenly realize they must leave now or they will be late for their appointment at an art gallery; they have on hold a small painting by a local artist. As they rise from their chairs, Raine suggests they meet in Paris for dinner the evening after next, at a restaurant Ned and Raine like best—she calls out the name and time and waves as she and her husband hurry away.

* * *

Initial impressions are as follows: Sam finds Ned to be not exacting enough, lethargic; his presence is not definite enough for his taste—he guesses that he is the type who appears this way no matter where he is. Yet Sam appreciates Ned's enthusiasm and interest in traveling, and he thinks Degas was an intriguing response—he considers his wife more than himself. Sam regrets he is not as selfless as Ned.

Ned finds Sam concrete but at the same time he appreciates

this about him. Sam is factual and familiar; he reminds Ned of his older brother, or, more accurately, how his older brother used to be before his addiction to alcohol and his subsequent refusal to communicate with him. Such thoughts cause Ned to become rueful.

Raine likes Lia's bright reserve, and Lia appreciates Raine's probing sense of the present; she has chosen to ignore Raine's moments of detachment, which she finds inauspicious. Ned thinks Lia is vaguely attractive but does not reflect on it. Lia thinks Ned is someone she can confide in and at the same time is puzzled why she would come to this conclusion when she's just met him.

Raine has been disconcerted by Sam's no-nonsense attitude—life does not flow in this way—and though his appearance is vaguely similar to that of someone she met years ago, his personality and mannerisms are very different. She finds it difficult to fathom him appreciating Picasso's work. And Sam regards Raine as someone he would never be attracted to—her body, her hands, and small visage are not synchronous—but there is something distantly familiar about her. Though he and Lia live in the South End, he supposes he may have seen Raine in Cambridge, where he often has meetings with clients or he and his wife dine with friends.

3

In the evening, on the plane ride to Paris, Raine leans in close to Ned; over the hum of the engines she says, "I am having second thoughts about meeting Sam and Lia for dinner."

Her tentativeness sounds purposeful, he thinks, and he senses anger too, which surprises him.

"Sam bothers me." Her voice wavering, she adds, "He's uneasy, and I believe he has a deceptive streak about him—it's subtle."

Ned puts down the book he's been reading. "Of the four of us, you were the one who was most enthusiastic about meeting in Paris. You are drawn to certain people, and then you hesitate. It happens all the time, Raine," he says quietly, uncritically. He then pulls up the shade covering the window, gazes out; both intrigued and annoyed by Raine's words, he's not sensed anger in them before. "Look how light it still is," he says.

"The longest day of the year," Raine responds halfheartedly.

When he turns to her, she peers into his eyes, which she

finds both warm and distant; she wishes she could penetrate his true beliefs. Though her thoughts drift as they usually do whenever she perceives this about Ned.

* * *

Once the plane lands in Paris, Raine is no longer concerned about the planned dinner with Sam and Lia. As they wait for their luggage, she reminds herself that she doesn't agree with Ned—he tends to generalize about her; she is convinced he does so to stifle any questions he himself may have about a particular situation.

* * *

Two evenings later: Raine, lying on the bed, a silk robe loosely covering her, while Ned, completely dressed, stands at the door, about to go down to the lobby. "What is on your mind, Raine?" Sitting up, she shrugs.

"Nothing."

"It is not possible."

"For you it isn't," she says. He goes over to her, cups her chin in his hand and kisses her.

Shutting the door to their room, he is bothered by Raine's lukewarm response.

As Raine slowly dresses for dinner, her mind is on Sam and Lia. It dawns on her the reason she was insistent about meet-

ing again with the couple is that she needs to know more about them. She is drawn to Lia, whom she may have an affinity with; at the same time she is concerned about—for no logical reason—the effect Sam will have on her and Ned. She views Sam as an impediment; she is apprehensive about him—he could change them in some way. Regardless, at this moment Sam shouldn't be a worry, what has been arranged has been arranged; she acknowledges she is getting ahead of herself. She gauges her appearance in the mirror; she has put on a black dress with narrow gold and black sleeves that outline her shoulders. Brushing her hair off her face, she is satisfied with how she looks, more so than usual. It is because they are in Paris, she assumes, and smiles. She reaches for her pocketbook, walks leisurely out of the room, wondering if she has kept Ned waiting too long. She steps into the elevator and presses the button to the lobby.

They are early and stroll easily toward the restaurant, which is seven blocks away. It is a serene evening, the air is mild and spirited, bringing to Raine's mind her most pleasurable moments in the city, that sensual meal a few years ago at an unknown restaurant in the Latin Quarter, the lingerie she purchased last year at a shop on a quaint street in St. Germain de Prés.

Looking over at Ned, she notices he is preoccupied, his expression fixed. "What is on *your* mind, Ned?" Once she has spoken these words, Raine regrets she has inquired. It would have been better to have diverted him with memories of Paris from their previous visit.

Whatever is distracting him from enjoying the evening, she guesses it is a minor matter he will work over in his mind and then will, on his own, come to one resolution or another. He often does not seek her advice unless it is something serious or involves her directly.

He stops walking and turns to Raine; his gaze is beseeching. Immediately she understands what is bothering him. "It isn't the time to talk about having a child, Ned," she says, her voice cajoling, her eyes strict, as she reaches for the collar of his shirt, pats it, then tugs it downward.

Until recently they've only discussed having a child in passing, but over the past six months Ned has spoken more directly to her about it. She walks again, at a quicker pace than before. "I don't think about it," she says, over her shoulder, with the same sense of provocative fun she would have had if she found an old tennis ball on the street and tossed it over to him. She does not feel attached to young children, doesn't comprehend why people like to fawn over them; it crosses her mind that she may be devoid of maternal feelings. She recalls how her lack of empathy for children and for one child in particular had changed the course of her life.

Most pressing are her recollections of her mother, alone with three children, more than a year after her husband's passing. She was the only one of the three who had been aware their mother was suffering. She would steal into her mother's bedroom late at night; a small lamp would be on. With a halo of light covering her face, her mother would be lying in bed, looking

up at the ceiling, a lost expression on her face as if she were as young as her daughter. Aware of each other's presence, neither she nor her mother would speak. Raine would then cross the room, climb onto the bed and sleep at the foot of it. Yet every morning facing her children, her mother presented herself as optimistic, spirited, and even as a child, Raine had comprehended how much effort her mother had had to exert in order to do so. Part of her resented her mother's sadness, but she admired her parent's resilience.

"Well, Raine, we are not exactly young," Ned answers pointedly, catching up to her. This startles her; she's never thought of herself as young or old, but always the age she is—from her perspective age is similar to a varying shade of a particular color.

She shrugs dramatically, causing her pocketbook to hit the side of her leg. "When we are back home, we can talk about it, Ned." Then she points to the Eiffel Tower in the distance, and says, "I forget how much closer it is to our hotel than I recall." But Ned doesn't raise his eyes to look at the structure; instead he steadily gazes at her as if penetrating her core and he isn't pleased with what's been revealed. Soon the moment is gone; his intensity has vanished.

He nods, but is annoyed Raine prefers not to talk about what he most wants. "Yes, Raine, we are traveling, but we have time to discuss it now. Once we are home, you will find another reason to delay. You've been doing so for months now." He wonders why she would not want to conceive in the city she loves best.

She walks at an even faster pace, hoping to reach the restaurant as soon as possible, not wanting him to bring up the subject again.

Ned watches her move adroitly ahead of him. The first time he spotted Raine she was chasing a young child across the scalding sands on a Florida beach, the noon sun shining down on her dark glossy hair. He was struck by her expression of fear. When he mentioned it to her after they had come to know each other, she told him she hadn't noticed him that afternoon, and they never spoke of it again. At the time, he understood she was embarrassed he had been watching her.

"Slow down, Raine; we're early," he calls out.

She looks over at him and smiles, enjoying how easily he strides toward her. "It is fun to be first—we can have a glass of wine before they arrive," she announces.

"Okay," he says, reaching her. Walking into the restaurant, they are flooded with memories of their past dinners there. They discovered it on their belated honeymoon. Raine pauses before they approach the host, reaches for Ned's arm to prevent him from moving forward and says, "This is our place—maybe we should not have invited Sam and Lia; it will become less important to us."

"We are only having dinner with them, they are not invading our lives. I wouldn't worry about it, Raine. Certain memories will not be erased."

Raine clutches his arm more tightly, thrusts back her head,

and says, her voice serious, "Ned, you are very solemn—it's not like you."

"You aren't yourself either, Raine."

"What does it really mean to be myself or you yourself?"

Through his disappointment, Ned smiles, and they both laugh.

They are seated in the area of the restaurant where they usually dine. Before opening the menu, Raine peers out the window, observes people passing by; slowly dusk begins to fall and soon pedestrians are encased in the dimming light and shadows.

Finishing his glass of wine, Ned checks his watch. "Sam and Lia are nearly forty minutes late. I wonder if they went to the wrong restaurant."

Raine shrugs. Fingering her gold necklace, she says, "Even though the restaurant is nearly full, because they are not here it feels that we have the place all to ourselves, Ned. Let's order!"

She assumes Sam and Lia have forgotten the name of the restaurant; she doesn't recall either of them writing it down or typing it into one of their phones. She remembers how confused they looked as she called out the name and time—they were in the fog of jet lag.

Ned's outstretched hands graze the white tablecloth; he leans forward and detects a sadness in her pale eyes: What is behind her hesitancy? Although he has told her otherwise, he believes it is not like her to be this uncertain. In many ways she puzzles him more now than when they first met.

Raine blurts out—"I believe Sam is unyielding—no, I know he is. I have made it a point to avoid people like him."

Ned, studying her, responds, "I take Sam as he is, outwardly confident, direct. We have only met him and Lia once; we may not do so again."

4

On the plane to Paris, Lia and Sam discuss how they might contact Raine and Ned. Their flight was delayed, and without realizing it—most likely because of Sam and Lia's growing jet lag that morning and Raine and Ned's rush to make their appointment at an art gallery—the two couples did not exchange information about themselves, not even their last names. They only agreed to meet at a particular restaurant in Paris two evenings later at a specific time. Although Sam was initially concerned, he is now less so than Lia; she believes they have not been thoughtful and should have anticipated something coming up. "We really don't know who they are—I liked them; I liked both of them. But I feel we weren't acting responsibly; we should have asked where they were staying in Paris, or at least exchanged cell numbers."

Sam shrugs—he doesn't agree with Lia, believes she is taking the situation too seriously. Sitting back in his seat and with a slight edge in his tone, he answers, "Things come up, I am

certain they'll understand. How do you know something hasn't come up for them as well? If we are meant to run into them again, we will. We should not worry about it. I liked them both too, though it would not disturb me if we never see them again. In life you talk with others while waiting in a long line, have an interesting conversation, and then you don't meet them again. It is the same thing."

Dubious, Lia responds, "It was much more than that, Sam. We agreed to have dinner with them; it was more than a conversation in a line while waiting at the doors of a theater, and we were not at an arena about to enter a sporting event. It was more significant than that. We spoke to them at length and we did not need to—we could have finished breakfast and gone our separate ways. You must admit we were drawn to Raine and Ned."

Sam shrugs again. "We are drawn to many people, Lia—it is who we are."

Not in the mood to discuss it further, she disagrees with him, believes their connection to people for the most part is superficial. She doesn't want to waste her energy arguing; it is never constructive. His indifference to social matters at times irks her but never for long. In this case she wishes she had taken more responsibility in getting the name of the hotel they were staying in in Paris, or finding another means of contacting them. Yet she isn't as decided as Sam is in not wanting to see them again. She is puzzled by his indifference; she understands her husband and knows he enjoyed the conversation that morning.

Lia finds Ned and Raine to be as compatible as a musical chord in a minor key—a tone that may be jarring at first, though soon resonates profoundly. Raine and Ned are not opposites, she believes, as she and Sam are. They are sort of off-beat too, which she appreciates. She thinks at times the life she and Sam lead is too practical, not adventurous enough; she likes Raine and Ned's unconventionality. They are not self-righteous as some unconventional people can be, but encouraging.

Disappointed as she is about missing Raine and Ned, she does not desire to go to Antibes with them. Best to stay with their original plan, she thinks, sipping from her glass of wine and looking past Sam and out the window at the sparse clouds and gray sky. They will not arrive in Paris for another hour and by then it will be two hours past the time of their arranged dinner with Raine and Ned. They may have been able to call the restaurant, but only discovered that the flight was delayed once they were on the runway and their phones were shut off. And it would have been difficult to call the restaurant without knowing the name the reservation was under. Lia closes her eyes, accepting that most likely they will not meet the couple again—though it is somewhat possible they could run into them in Boston or Cambridge.

Her regret in not seeing Raine and Ned subsides; her musings turn to Paris and what she'd like to do in the few days they have in the city—they had missed visiting the Gustave Moreau museum when they were there two years ago. She does not have

a strong preference for Moreau's work—she finds it obscure—but she likes that the museum is in the 9th arrondissement. Their favorite hotel is only a few blocks away. A bemused smile crosses her face, the expression in her eyes less hopeful than usual; their previous visit crosses her mind, and she recalls how late one afternoon Sam had taken a walk while she had showered and when he had not returned after a few hours, she had begun to worry. She tried his cell but was not surprised when he did not pick up; he often leaves his phone on mute. Thirty minutes later, she heard a knock on the door. Her heart pounding, she went to open it. Sam stood there, his face flushed, his eyes lowered, and for a moment she wondered if it was a mirage. As she was about to say how worried she'd been, he pointed across the room and she saw his hotel key and cell phone beneath the large print of Picasso's *Le Repos* he had purchased the day before and had placed lengthwise on the bureau. She threw her arms round him and as she did so, he pulled out a box from his back pocket and handed it to her. When she opened it, on the cotton filling lay a delicate gold bracelet. She peered up at him, not knowing what to make of his absence, and his gift to her.

Paris—she has been there often enough that she no longer views it as a naïve tourist would.

Glancing over at Sam, she sees he is asleep; she studies the sharp turn of his nose, the roundness of his chin, the wispiness of his brows and she experiences a deep sense of uncertainty. She closes her eyes, wills herself to feel steady again; leaning

across his seat, she closes the window blind. She reaches down and withdraws a novel from her tote bag, puts on her glasses, and begins to read. But soon she closes the book. She feels a pang—of loss? Of love? She is not certain.

5

Two days later, Ned and Raine lunch beneath the gold and blue canvas awning of an outdoor café across from the Musée d'Orsay.

A warm but overcast afternoon, and like the weather, their presence is muted. Ned, disoriented from the long wait to get a table, sits back in his chair. In her mind, Raine lists all the places she wants to visit before they leave the city.

Across the narrow street, exiting the museum, Sam in his exacting way tells Lia about his exchange with the cashier. While buying two art prints at the museum shop, the clerk ignored Sam's attempts to use French, requesting that he speak English. Lia doesn't respond directly to his complaint—she just walks on, smiling quietly.

While Raine is distracted by two women passing their table—one is wearing gray pants and a white top and the other white pants and a gray top—Ned catches sight of the couple.

When Raine loses interest and turns away, she sees that Ned has left the table; he's walking away, waving his arms. Soon Lia and Sam approach their table and Raine experiences a rising anxiety; reflexively she smiles and stands up to greet them. She hugs Lia and then Sam.

Facing one another at the small circular table, the four of them burst into an embarrassed laughter.

"What happened?" Raine cries out. "Did you not know the name of the restaurant? We should have written it down for you—we were in such a rush. Or were you avoiding us?"

They all laugh again.

"No, our plane was delayed," Lia says regretfully. "We did not know how to reach you. It hadn't occurred to us to exchange cell phone numbers, last names—we were careless," she says, shaking her head.

"I guess you could say we too were thoughtless" Raine says. Because of their joint carelessness they are more comfortable with one another, more than they were in Edinburgh.

Raine suggests they order a bottle of wine, and signals for the waiter. Once it is served they touch glasses. "To a long friendship," Raine says. "And to Paris," she adds. There is a slight edge in her voice now, and she continues, "Well, we are all together, at last."

"Yes, at last," Sam says both agreeably and strictly, with a sidelong glance at Lia. Detecting a slight mocking tone in her husband's words, she smiles warily, wondering if Raine and Ned

might view their "flight delay" as an invented excuse. Lia thinks of Ned's adroit steps, his broad smile as he rushed over to greet them.

* * *

In the evening the two couples dine at the restaurant where they planned to meet two nights earlier. Lia and Raine become immersed in a conversation about their work—Lia is beginning to question whether or not she should continue teaching, and Raine is disappointed she has not found an interesting freelance project in a while. Ned and Sam speak of sports, the Boston teams, which ones they like and which ones they don't. They refrain from mentioning their careers. Ned does not like to acknowledge he is a committed journalist—he finds in general people, no matter their political leanings, liberal, conservative, or centrist, are suspicious of the profession, and Sam more often than not declines to tell people he has an MBA from Harvard—people tend to dislike the world of finance and Harvard.

Their waiter is a small, narrow man with a dark mustache and brown straight hair close to his head, like a cap; he wears a white jacket that is large for him. Lia is the only one who has noticed him throw salt over his shoulder before removing their dishes from the silver tray on the stand behind him, then gingerly serve them.

After dinner they stroll toward the Seine and soon are standing in the spray of light that flows from the Eiffel Tower

to Notre-Dame. Boats filled with tourists putter up and down the river and Raine suggests they take a ride on one. But Ned and Sam are not interested—they dislike the idea of riding on a crowded boat—and as Lia is only mildly intrigued, they decide against it.

All are tipsy. Sam is more gracious and optimistic after having had a few drinks, Ned solemn, Lia quiet, and Raine energetic—her desire is to go dancing.

6

Once they part from Raine and Ned, Sam is uneasy; the effect of the alcohol has worn off. Sensing his discomfort, Lia grasps onto his elbow, suggests they walk more. She is invigorated by the soft night air and could walk for hours. But soon they hail a taxi.

Instead of going into their hotel, they stop in at a café nearby and find a small table outside. Overhead, the stars are barely visible. Other than Lia's occasional comments about the stark whiteness of the moon or the gentle night air, they are mostly silent.

Sipping his amaretto-laced coffee, Sam wishes he were back in Boston—he needs to find a new job by the end of summer.

Lia has had too much wine—the events of the day, unexpectedly meeting Raine and Ned, the extravagant dinner the four of them shared, and images of tourists and natives of Paris she's seen walking about the city flood her mind; overwhelmed, she feels a headache coming on. She orders a Perrier and once it

is before her she pulls out a bottle of Tylenol from her pocket-book, takes two out, and swallows them down with a gulp of sparkling water. Almost at ease now, hoping she has taken care of the headache before it intensifies, she sits back in her chair, smiles loosely, watching the pedestrians pass by. How fatigued she is from the day and evening and how pleased she is that they have run into Raine and Ned. She would have been troubled if they hadn't met up, something left undone; all of them had been thoughtless, maybe purposely so, she wonders.

She looks over at her husband; tilting her head to get a better view of him, she smiles. He catches her gaze and says, "You must be pleased we had dinner with Ned and Raine. It is what you were hoping for." He sounds vaguely dismissive at first but then encouraging—for her sake. She frowns when he turns away to look in the direction of a saxophonist, who has started playing across the street.

"Apparently, you enjoyed the dinner," she responds quickly, her voice thin. He nods. She hears the quickening of his breath.

From time to time Sam is puzzled by Lia's need for balance and order. He prefers the ups and downs of life. He regards himself as personally free and never considers he probably is not, but the truth hovers at the outskirts of his mind like a muted yellow light he readily ignores. He refuses to admit to himself how much he actually likes the structure involved in his work.

Lia gauges her husband, who will turn to listen to the saxophonist at one moment and then at the next will look over at the entrance of the café and steadily watch the people entering

or exiting. No matter how much he has had to drink, he is sharp-eyed, always assessing. How opposite they are from each other, she thinks, but that is what makes their life together intriguing. She can't take the cold and he can. He has a few intimate friends while she knows many women she likes to converse with, more often in a group setting than individually. Sam has told her once that he is more like his mother in this way—his father is social and has a myriad of acquaintances. Lia deeply comprehends how she and Sam have gravitated toward each other—their differing natures and tastes have made the attraction between them stronger. Yet again she experiences a pang of loss.

* * *

Raine looks out the window, her forehead pressing the pane; she clasps her small hands behind her long back and says, "Ned, the café across the street is still open." She then turns to him; he is resting on the bed, fully dressed, on top of the covers, his eyes half-closed. "I'd like to go out again, Ned, walk more, maybe sit out at the café—our room is *stifling!*"

His voice groggy, he answers, "Not tonight, Raine; we've had too much to drink and eat, and we've walked for hours today. It is after 1 a.m." And fleetingly she thinks how she met Ned in the early morning hours; he was working as a hotel clerk, a little disheveled, his hair tousled, but not sleepy at all. The early morning hours seemed to suit him, she had thought. She had immediately been drawn to him, his unkempt appearance. She

is warmed by the memory, but disappointed that he does not want to go out now.

"It's been a long day, Raine."

"Yes, it has," she ruefully acknowledges, hearing frustration in his voice, knowing these past few days she has let him down by refusing to discuss what is important to him.

"In Antibes, it will be easier to walk around late and into the early morning hours," he replies evenly, eyeing her. "Our trip is only two days away." Then he wonders if he sounds too final; she appears downhearted and he hates to see her this way. He sighs and says, "Let's compromise. We could stay close to the hotel, go to the café across the street. Will you agree to that?"

"Yes, of course!"

Getting up, he smiles and approaches her; she is a magnet drawing him close. Her eyes intent, she watches him come toward her; in such moments she always sees him as the uncombed hotel clerk. To him she is the exotic and confused woman who walked into the hotel at one in the morning. Within minutes they have forgotten about going to the café and are in bed, beneath the cool sheets.

* * *

Lying in bed, Ned and Raine look up at the ceiling. Her voice dusky, she asks, "What do you see, Ned? I adore the ceilings in this hotel—no matter the room we stay in there are fascinating designs. It's the same as looking up at the clouds, but a ceiling is

stationary—you have time to think more about the pattern and how it is repeated."

Ned does not want to ponder the design on the ceiling, or its repeating pattern. Raine is a visual person, and he prefers to interpret words. It is the main difference between them. Other than that they are like hand and glove, he thinks. But he acknowledges this particular difference helps shape their perspectives on the world. He squints, attempts to visualize an image in all the swirling lines. "I see a dog, or maybe it is a cat, hiding beneath a table," he says lazily.

"Ned, you do not see anything. Where is the dog or the cat? Where is the table?" Raine asks. And they both laugh. He takes her in his arms and cradles her, not in a protective way but to hold her together; he does not want whatever it is that makes her compelling to peel away.

7

Over a late breakfast the next day, Raine convinces Sam and Lia to go to Antibes for the weekend. At times she sounds adamant, pleading at others, Ned thinks, remaining silent; he doesn't understand Raine's need for Lia and Sam to join them— he finds it irksome and yet vaguely pleasing.

Twenty-four hours later, the two couples, chatty and with good intentions, board a train to the south of France. At first Ned and Raine sit together, and after twenty minutes or so they change seats.

Raine and Lia, next to each other, speak about a movie filmed on the Riviera. Lia guesses that having watched the movie may be what has prompted them to change plans and travel to Antibes instead of Burgundy. The scenery was breathtaking, and though the characters and story were not that interesting, she would see it again because it was beautifully filmed; the camera focusing on the wide and blue

Mediterranean Sea, the purplish hue over the mountains. Raine shrugs and says she was not that impressed with the movie—too slow-moving for her.

Across the aisle, Ned discusses politics with Sam; he stands next to the seat where Lia was sitting, his arm across the headrest; he leans toward Sam, who, looking up at him, rests his head against the window.

After a while Raine calls out to Ned, tells him that Lia's reaction to the Riviera movie was the same as his. This arouses Ned's curiosity; spontaneously he turns and goes over to speak to Lia. Raine moves out of the seat so that Ned can be close to Lia.

Raine sits next to Sam. Sam looks out the window at the French countryside as the train rolls by, and Raine picks up a magazine from the pouch in front of her seat and begins to rifle through it. "Oh!" she suddenly exclaims.

Sam abruptly turns to her. "Something wrong?" he asks. Their eyes meet intently for a second and then immediately they each look away.

"I was just reading about Antibes—there have been break-ins in the hotels in the old section of the city."

Looking out the window, he says, "We are not staying in the old section. I wouldn't worry about it."

Raine doesn't respond. He's breathing more heavily, she notices, and she isn't certain if he is trying to allay her concern or add to it. Then she sees he is peering across the aisle at Lia.

As if sensing his gaze, Lia turns to her husband; her expression is wrought with concern as is his, though for different reasons.

Sam and Lia

8

On a frigid January afternoon eleven years before, on a trolley car that had stalled for ten minutes between the bowels of Park Street and a well-lit Copley Square, Sam, who'd been reading a pamphlet, looked up and noticed Lia. She was sitting across from him, shivering, though her expression was stoic. When the car began to move, she rose from her seat. Maintaining his balance, Sam approached her; the trolley came to an abrupt stop in front of the Boston Public Library. Once they alighted, his voice husky, he said that he saw how cold she was and guessed that she wasn't accustomed to the northeast climate. He asked if he could buy her a hot chocolate. She gazed up at him, her skin pale, her smile firm—she slightly raised her brows. He did not know if she was suspicious or surprised by his offer.

He led her to his favorite coffee shop only a few blocks away, and after drinking hot chocolate, which Sam claimed was not hot enough, he went back with her to her apartment.

They talked through the early evening. He discovered then that her family name was Marst and she was from Richmond, Virginia.

When she offered to make dinner, she sensed his hesitancy. He stood up, put his hands in his pockets, and said he had to leave, his expression strict, his words decisive. She went to the closet to get his down jacket. She thanked him for the hot chocolate and began to contemplate what she would do that evening. When she was about to close the door, he turned back and said that he'd call her soon. This puzzled her but she smiled and nodded.

But later, the more she thought about it, the less puzzled she was, realizing he had only said that he'd call her to avoid ending their meeting on an abrupt note, to be polite. She also was disappointed he hadn't stayed longer—making dinner would have been her way of thanking him for noticing how cold she'd been in the trolley.

Since her late teens, Lia had been longing for something or someone to nudge her from her reserved nature. When she and Sam had been conversing in her apartment, finishing up their glasses of wine, she had looked into his piercing eyes and fleetingly had wondered if he was the one who could do so; she had spent all those years holding herself in, refusing to become like the other freewheeling members of her family.

* * *

That evening, as Sam rode the elevator down to the lobby of her apartment building, he realized there was something about Lia that could easily draw him in. Maybe he wasn't ready to be drawn in, he reasoned. She was familiar to him and different at the same time. Several times she had used a word both his mother and grandmother often had—"invariably." Whenever he'd call his mother to tell her about one disappointment or another, a grade lower than he'd expected, or that he was no longer seeing the woman he'd been involved with, she'd say in an even, factual way, "Invariably you will get over it, Sam—you are strong and more determined than most."

Whenever he'd ask his grandmother why the colors in her paintings were either very dark or very light, she'd respond, "Invariably it has to do with my mood at the time," and then she would smile; she had never taken herself that seriously. Both his mother and grandmother had used "invariably" as a signal to him to accept the inevitable.

As he strode toward his apartment, he thought of Lia's words, "Invariably, I chose to come to Boston because I liked the college, and wanted to explore the city." He relished the lack of undertones in what she said. Uncomplicated. Fine.

9

Sam called Lia on a Saturday afternoon in late March. He apologized that it had taken him so long to do so. He said he'd been busy at work. It was his first year with the company, he had only been working there for so many months. He had graduated from college not even a full year before.

Lia sensed the suppressed anxiety in his voice. He then told her, his tone almost defensive, that she'd kept coming to mind, the conversation they had had in her apartment; it had been a constant reminder to him to contact her.

* * *

The following Friday evening, Sam and Lia met in the Public Garden; there were only traces of snow, and it wasn't as cold as it might have been.

Lia arrived before he did and had been waiting for him as

planned by the statue of George Washington. Sam, approaching, saw her first. She was looking away, her head slightly turned. He followed her gaze; she was watching a sidewalk artist paint—he couldn't see what—and her expression was focused, her lips parted. "Invariably," he thought. "Invariably, we will be together."

Once she turned back, they made eye contact and reflexively began to walk toward each other, both smiling.

Lia, reaching out, touched his arm, her expression impassive, but understanding in how she dropped her gaze, and he was encouraged—she was not disappointed in him for taking two months to contact her.

Over dinner, they did not engage in a long or deep conversation, but in mellow tones they spoke of trivialities, about their work, how their weeks had gone, and often avoided meeting each other's gaze. Lia wore a short skirt; Sam's ruddy complexion deepened whenever she tightly crossed her legs.

When they left the restaurant, they felt drops of water and soon a steady slanted rain was falling, then a downpour. They hailed a taxi and during the ride they again were mostly silent. Lia gently rested her hand on his knee and Sam felt at peace, but when the driver asked where they wanted to be left off, without hesitation they each gave the address of their respective apartments.

* * *

On a Sunday in early May, Lia called and suggested that he come to her apartment, that she'd make lunch for him. He heard something in her voice, an insistence, a longing.

A steady, musky rain fell. When she opened the door and glanced up at him, she saw that his hair was slightly wet. Briefly, pensively she gauged his eyes, but he didn't meet her gaze. He was dislodged and happy at the same time. Impulsively he picked her up and carried her straight to her bedroom. Once they were lying next to each other they began to laugh.

After they made love, Sam was inspired and at ease; he understood his life undoubtedly was on the right course. He put his arm around Lia and she rested her head on his chest. He decided he would tell her his story, what he had hoped to say to other women he'd known before but had not quite trusted enough to do so. He began by saying that he had been born on a dreary day in early November, and had been named Samuel Stanley Stephens. His parents had believed they would never have a child—he was a surprise.

10

Sam's parents, Naomi and Jack, met the summer following their first years of college. It was the mid-seventies and there was a general malaise in the air, a near perfect reflection of their own existences—it was as if the world on the whole, like their lives, was on pause.

The previous spring, once signs of summer's approach had become evident—in Jack's case, an intermittent balmy breeze off the Charles River, and for Naomi an unexpectedly light-filled breakfast room in her dormitory—they each had experienced a muted sense of hope and had begun to look forward to the next season, viewing it as a reprieve, a time to reassess.

On a late March evening, while watching a Celtics game and drinking with high school friends, Jack casually had mentioned he was looking for a summer job; promptly he was told about an establishment that was looking for summer help. And Darlene, Naomi's roommate, whose parents lived in a well-manicured

suburb west of Boston, had suggested that she apply to work at the restaurant her family owned. Her father had found his daughter's friend Ms. Presser—as he liked to refer to Naomi—intriguing; he viewed her as somewhat restive, yet competent, intelligent.

The restaurant was across from a well-known beach south of the city. Jack had been hired to be both a fix-it man and a valet. And Naomi, who had filled out an application to be a waitress, was transferred after her first week to the position of hostess; her approach to serving tables was regarded as much too thorough.

Naomi and Jack became acquainted on an evening only a few customers had come in to dine. He was the lone valet. It was a very warm June night, unseasonably so, the hottest to date of the young season. Jack, who preferred more temperate weather and had not been diverted by driving and parking other people's cars, had become intensely aware of the heat. He decided to wait out the evening inside the air-conditioned foyer.

Naomi, who preferred hot weather and was pleased the air conditioning seemed more mild and less effective that night, was becoming impatient—she was miserable whenever she felt she was wasting time. Standing behind the hostess's wooden lectern, she looked about to see that she was alone; her shoulders straight, her eyes alert, she cautiously lowered herself downward, reached out and grasped a book she had positioned on the floor close to her feet. Gingerly she stood up and placed the novel beneath the pile of menus covering the lectern, then checking

again to be certain no one had entered, she lifted the *cartes du jour* to read from her book.

Moments later Jack walked in; his gaze rested on the hostess at the lectern. He smiled. Not having noticed her before, he tried to imagine what she would look like once she raised her head. But also he sensed her worried nature. Mostly devoid of anxiety himself, he was touched by her presence; his tendency was to feel protective toward those who were apprehensive.

Ten minutes later Naomi lifted her head and she spotted Jack, who was leaning forward against the door, peering out, his back to her. "Oh, no," she said quietly. And he turned round. He assumed she had reacted in this way because she thought she had been caught reading on the job, and at the time she had believed so as well. Later, though, she would acknowledge that on an intuitive level she had realized that Jack was a kindred spirit. He had dark hair and was well built and nearly but not quite tall. When his blue eyes met her concerned gaze, she relaxed.

Jack initiated the conversation. Slightly tilting his head to the side, he said, "Wish I'd brought something along to read— wise of you to do so. You never know when it will be a slow night." He avoided looking directly at her again.

Refusing to acknowledge he had noticed her reading, Naomi answered precisely, softly, "I do not know who you are. Do you work here?"

With purpose Jack approached the lectern but was careful not to stand too close. Her deep green gaze assessing, objective, Naomi studied him. It unnerved him for a moment and he forgot

that just minutes before he'd felt for her, her anxiety. He hesitated, then told her that he was working at the restaurant only for the summer, that he was a student at MIT, had just completed his first year. That he'd been employed as both a fix-it man and a valet.

She slowly nodded as if she didn't quite believe him. "Do you like it there?" she asked, expecting that if he did attend this college he would; she'd been told by other students that those who went to MIT were the type of people who would like it very much.

He shrugged. Speaking smoothly and earnestly, he said, "I'm different—I need a social life more than the others do." Again he tilted his head to the side. "Maybe? I like the challenge though, the courses, I mean."

Naomi eyed him, his ready smile, his balanced physique, gleaning that the other male students were probably jealous of him, his ease, his attractiveness. Those she had met from MIT were inclined to be quiet, not particularly social.

"Yes," she said, meeting his gaze, her expression sympathetic. Then she became quiet, still, apparently lost in thought.

"What about you?" he asked.

Naomi looked away, her eyes quizzical; she explained in her painstaking way that she was unhappy with the college she had chosen to attend, an all-women's college. When she had visited Boston with her mother the spring of her senior year of high school, she had found the city quaint, the people polite, and had been convinced it would suit her. But a few weeks into her first

college term she felt disconnected not only from the school but from the city as well. "Boston in various ways is colder than New York—it's where I'm from," she said, turning her gaze to his; Jack saw a glimmer of hope in her expression. She continued, saying she also had come to realize that Boston in general was subdued, much less hustle and bustle than what she was accustomed to in her city.

Jack nodded in agreement and said he was from the Boston area, but he liked to drive into New York with his friends, attend a concert, go to a Rangers-Bruins game or see the Patriots play the Jets; it was an exciting place, like no other. But if he lived in New York City, there would be no New York City to visit.

Naomi briefly smiled, then said she had not looked at it from that perspective.

"You always have to swivel your thoughts, your impressions around until you get the best angle on them," he responded with a smile.

"Yes," she answered, "true to a point, but maybe it would have been healthier for me to have chosen a coed school." She refrained from mentioning to Jack that interacting only with women academically was somewhat confining.

Then she acknowledged that by staying in Boston for the summer she was giving the city another chance, adding that maybe this was her version of swiveling around her thoughts and impressions. She'd heard the city was beautiful at this time of year. If by the end of summer it didn't meet her expectations she would apply to transfer to another college. Yet she was still

hesitant—if she had made a mistake about Boston, she could easily be wrong about another city.

Jack, struck by her honesty, answered with a quiet fortitude, his voice husky now, saying that he believed her expectations would be met. His gaze found hers and he smiled and she returned it, albeit with a faint skepticism.

The guitarist who played on certain nights emerged from the restaurant, having finished his gig early; there were only a handful of customers and as the air conditioning was ineffective, he appeared worn, his forehead moist from the heat. Upon seeing the young couple he began strumming a tune neither Naomi nor Jack had heard before—it was low and dark, only a fleeting strain of lightness, unflinchingly erotic.

* * *

Their general discontent was what bonded them. They called themselves friends for nearly two months, but in the depths of August, they became lovers; Jack was surprised and gratified by how Naomi would coolly take his hand and expertly guide him.

In terms of appearance, they were an attractive couple; Naomi was slightly above average height and slender, her chestnut brown hair framed her face perfectly and brought out the color of her eyes, and Jack was undeniably attractive mostly because he didn't realize he was. Although they were more compelling to look at as a couple than they were as individuals, their personal-

ities were somewhat idiosyncratic. Naomi never had been much interested in her appearance; she was more fascinated by the novels she read. And more often than not she dressed in blue jeans and T-shirts, and rarely wore makeup. Jack was charming, inoffensively so—yet he'd refer to himself as an engineer; it was his bottom line.

Once they each graduated from college, they moved to New York, where they lived for two years; the firm that had hired Jack had placed him in the city—it was understood that after twenty-four months he would then return to the Boston office. Upon their arrival in New York, Naomi signed up for lessons in the Stanislavski method, though after six months she withdrew from the program; she clearly understood she was not meant to be an actress.

As a young couple, Naomi and Jack's existence was more serious than many others of their age group. On occasion they would attend a party together and would part soon after entering the apartment or home where the gathering was held; each would find themselves conversing with a small group primarily of their own sex.

In terms of their careers, after deciding against becoming an actress, Naomi would work temporary jobs and volunteer reading to people in nursing homes and hospitals, and within a few years she found her niche as a narrator of audio-taped books. Jack was talkative, articulate, and had the ability to put people at ease. He had been trained as an engineer but his employer had decided that Jack was a gifted salesman as well;

once he was settled in the Boston office he'd travel frequently for his company to pitch their product, which often left Naomi alone.

* * *

After five years of marriage Naomi and Jack accepted that without medical intervention, which they had refused to entertain, along with their firm decision not to adopt, they would never have a child. Yet two years later, at the end of a routine medical check-up, Naomi's doctor informed her that she was pregnant. She was stunned but did not express it to him. What she had learned most in her short stint of acting classes was how to control and channel her feelings. She sat quietly, unemotionally across from the doctor; he wore a dark gray suit with a vest, his hands clasped atop the desk. The sleeves of his jacket were more worn than they had been on her previous appointment nearly a year before.

She would always remember the moment he gave her the news; though the doctor's voice was dispassionate, his eyes searched hers as thoroughly as her father's had when she was in high school and would refuse to say hello to their guests whenever her parents entertained—her reason would be that she needed to work more on an English paper. Her father, a judge, more than a decade older than her mother, would chide Naomi for her assiduity, which he found extreme; in a low, penetrating voice, he'd say, "Naomi, you will never see the forest—you are too tied to a damn tree."

As the doctor spoke, what she first comprehended was that her life, her expectations had been abruptly transformed. When she had not conceived after five years of marriage that had followed two years of living together, she had imagined that she and Jack would continue on as a childless couple. She had created in her mind an alternative life for them, one so vivid it became a natural part of who she was—independent, almost carefree. Now that that reality no longer existed, she was jarred, more so than she'd been when she had believed she would never carry a child.

She nodded at the doctor, her eyes steadfastly following his, though her heart was fluttering uncontrollably. He wrote out a prescription for the vitamins she needed to take and told her to come back to him in a month—he wanted to evaluate her progress. And she gathered he was as surprised as she was by her pregnancy.

She waited a week before telling Jack or her parents—it had taken her that long to digest the news. Once she was at ease with it, she began to willingly accept that she would be a mother. One Friday evening, she told Jack to dress up, that she'd take him out to dinner. Jack, always happy to see someone, anyone, elated, especially Naomi, did not ask what the occasion was but instead calmly and pleasantly awaited her news. As he dressed that night, he asked if he should wear a bow tie; she paused, and said, "Yes, Jack, I think it would be very nice," her voice upbeat. When she smiled demurely, without her usual skepticism, his curiosity for the first time was aroused.

* * *

They named their son Samuel Stanley Stephens—the Samuel was after Jack's great-grandfather, born in Nova Scotia. Stanley was Naomi's chosen diminutive for Stanislavski—her son would be a subtle reminder of those six months of acting classes; he would represent part of a chosen past experience that had been appreciated and then decided against for reasons that had more to do with compatibility than dislike. Also, Stanley was better than her maiden name, Presser.

It was the acting classes, she believed, that led to her finding her true career as a professional reader. After five or so years, her taped readings of books, especially of Emily Brontë's *Wuthering Heights*, had become quite popular. Naomi possessed a pleasant, precise voice, not overly expressive, but with a heightened sensitivity.

As they had not expected to have a child, they were uncertain, each in their own way, of how to cope with their son. As a baby, Sam had been for the most part calm and content yet had the tendency to erupt into fits of screaming every so often, especially when least expected. If Naomi and Jack were planning to attend a party or see a movie and their baby was in one of his moods, his face reddening, his cries piercing, they would call the sitter to say she would not be needed that night. At first they were very concerned. Naomi, low key and contained with a purring smile, one not of contentment but of ponderosity, would become disoriented; she would tightly hold her son to her chest, a

lost expression crossing her face. Jack would pace and shake his head; he didn't think the baby sounded quite right. Eventually Sam would stop crying and his parents, given their respective natures, would forget about it until another outburst followed a month to six weeks later. By his first birthday the screaming fits had ceased.

* * *

Young Sam had a strong, stocky build and ever since his first steps he tended to walk in a snake-like fashion, feet close together, slithering forward, his shoulders relaxed and slightly ahead. He spoke his first words slowly, with a shushing quality in his voice; the first one he uttered was "so." It was as if he were trying to please both parents, intuitively navigating between their two personalities, until his "so" became a "no," which sounded abrupt, even for a young child.

When Sam was eighteen months old, his father considered legally changing the *ph* in Stephens to a *v*; he thought it would be easier for Sam to write once he started school. But Naomi thought about it and wondered if this was because of Sam's past crying outbursts, that Jack did not want to irritate his son in the near future. When Naomi explained it to her husband in this way, he agreed to spell his surname as intended.

Jack, not inclined to meet the gaze of a person he was talking with, was well-liked because of his overall upbeat presence. It was as if he threw about his warmth as he would have a

gaze. When he wasn't among a group of people, he tended to become melancholic, and so he made certain to be with friends or colleagues, especially those who admired and appreciated him. In order to boost his spirits, especially during those long, tedious Massachusetts winters, he would travel on weekends to a cabin he'd purchased in northern New Hampshire; he'd usually invite a friend or two.

Naomi preferred warmth and would sit at home in the South End and read in front of the fireplace, bask in the heat from the flames, refusing to travel to Jack's cold cabin in the north.

Naomi and Jack were conscious of how their son Sam viewed them. Naomi believed Sam regarded her warily and that he preferred his father's company because of Jack's smile and because of how her husband would grasp their son under the arms, raise him up, and hold him high above his head, even when he was no longer a toddler. Whenever she mentioned this to Jack, he'd say, "That may be true, but Sam loves you more."

* * *

When Jack was away, Naomi often would bring her son to New York to see her mother, who had been widowed a month before Sam's first birthday. Sam was mesmerized by his grandmother's drawings and paintings. He particularly liked how she painted trees and clouds, especially very tall trees.

On one visit, Sam, now nine, discovered a sketch of his mother and father in the closet where his grandmother kept her

drawings. It is of Naomi and Jack, in their early twenties, walking down 54th Street on a windy day, holding hands, gazing in opposite directions—the hem of Naomi's dress is lifted and Jack's jacket is flapping open—their raised heads reveal their sharp profiles The sketch is based on a photograph his grandmother had taken of his parents not far from her apartment building. Yet in the photograph, though their gazes are averted, Naomi and Jack are not holding hands. This bothered Sam, and the difference between the photograph and the sketch would often cross his mind.

Sam's deep and sensitive appreciation of his grandmother's drawings and paintings surprised Naomi; she found her son quite grounded in all other respects and envisioned his future profession as one of a surgeon or a dentist.

Not only did Sam enjoy going into the city to see his grandmother and her artwork, but in her presence he experienced a steady emotional sense that was wavering in his mother, and suppressed beneath his father's joviality. She was the anchor for him, the answer to his parents' personalities. He was aware that his parents tried; his father would bring him to Red Sox games, and Sam appreciated the effort his mother would put into preparing his favorite dessert—it would take Naomi hours to make a banana cream pie, but later he would acknowledge that, though he was touched by how his parents had tried to extend themselves to him, they never had been full throttle.

An incident occurred when he was eleven that would stay with him and would bind him forever to his grandmother. She had

recently moved to Florida; she was sketching more than painting by then. His parents had sent him to stay with her during his February vacation; Naomi and Jack had decided to travel to Costa del Sol. Years later Sam would realize they had done so in order to repair their marriage, which had needed fixing. Over the years they had spent too much time apart; his father's travel schedule had only increased, and his mother as always would refuse to go with her husband to the cabin in the north. Had one or the other of them had an affair? Sam would never know but acknowledged when he was much older that their trip to Costa del Sol was a sign that they had chosen to remain married. At the time, however, he was simply hurt he'd been excluded. His grandmother had noticed how glum he seemed. And she began to divert him. She'd take him nearly every day to the beach, and sometimes to the jungle zoo. He'd notice how she walked more quickly than his mother.

On that trip he realized his grandmother had two opposing sides—when she was sketching or painting she was thoughtful, careful, but when she was out and about she was fast-moving. He found his grandmother's dart-like pace encouraging, uplifting, and in her company he felt like a different person, an optimistic one, no longer needing to negotiate between Naomi and Jack's personalities.

On that visit, Sam, one evening, while shopping with his grandmother, inadvertently distanced himself from her; she was rushing ahead to buy a short-sleeved shirt for him and the store was about to close. Sam lingered behind to check out a video

game he'd been interested in getting. He heard on the intercom that the store was closing. He looked about but could not find his grandmother. He stepped forward, searching for a security guard. Soon he spotted his grandmother outside the heavy gate at the front of the store, rattling it, crying out that her grandson was inside. As he approached, he saw tears flowing down his grandmother's face, and her immense relief when she noticed him coming toward her. He would never forget this experience— he had understood how much she valued and loved him.

* * *

Sam was a serious student in high school, a little overweight, and considered a good friend by the opposite sex. But in college Sam was quite popular, no longer stocky—he was now five foot eleven inches, an inch taller than Jack. Women who were attracted to men who had definite opinions and specific preferences liked him, while others who wanted a more philosophically oriented boyfriend found him disappointing. With every pronouncement of Sam's, whether it was his favorite flavor of ice cream or his favorite historical figure, there would be a wistfulness lurking beneath his confidence.

As direct and assertive as he was, Sam had a natural affinity for making women feel they were in charge. However, these very same women would soon become discouraged—although Sam willingly followed through on superficial commitments, he was not able to make long-term ones. He appreciated each woman

he became involved with, though he would eventually decide in that no-nonsense way of his why each one was not the best life partner for him, for his goals, even though he was not quite sure exactly what he wanted to do, who he hoped to become.

He graduated from college with a degree in economics, and without a partner of any sort—the truth was he'd not been looking for one; as the only child of Naomi and Jack he held a somewhat shaded view of relationships. Sitting through the long and drawn-out graduation ceremony on an unseasonably hot May day in the northeast, Sam thought over the past four years and concluded that, as unfortunate as it was that the time had passed so quickly, he was completely ready to face the next stage of his life.

And facing the next stage of his life would prove to be a little more challenging than he'd anticipated that hot day in May—despite his Ivy League degree, and that he had done better than well enough in his studies, it had taken him seven months to find a job. The economy had not been in great shape, but began to rebound in the late fall.

At the most discouraging point of his job search, he approached Naomi and Jack; he wasn't without hope but needed guidance—his grandmother had passed away the previous January. They invited him out to dinner. Earlier that day Naomi had completed one of her taped readings, which she thought had gone extremely well, and her agent had informed her that she might be up for a role as a voice-over in an animated movie. Jack had just returned from his cabin in New Hampshire.

Over dinner they pointedly reassured their son. As Sam spoke of his difficulties in finding work, Jack's mind was filled with images of the weekend he had spent hiking in the north country with two friends. Naomi was still in the thrall of how well her reading had gone and the possibility of her voice in a Hollywood movie. Out of respect for Sam's worried state, though, they did not verbalize their joyful feelings.

Sam's gaze, his eyes the same blue as Jack's, shifted from one parent to the next. Then Sam suddenly stopped gauging his mother and father; it struck him that, despite their encouraging words, they clearly were unable to empathize with his concerns, his subtle feelings of displacement. Crossing his mind was the snapshot of his parents walking together on a windy day in New York. And for the first time he comprehended his grandmother's sketch of the photograph: *Naomi and Jack, gazes averted, hands entwined, for ever.*

11

Sam's description of his parents was based on what Naomi, Jack, and his maternal grandmother had told him, along with his ability to extrapolate. Once he finished speaking, he took a sidelong look at Lia; in her gaze he saw kindness, equanimity. He sighed and said that his grandmother had passed away the previous year. "I stayed on in Florida for a few weeks—my parents needed to return to Boston. I offered to help sell her home, look for a real estate agent. My mother's brothers and their families had to return immediately as well. I was the only one who had the time to stay. I left my grandmother's home—I wanted it to look presentable—I rented a hotel room and on most days I sat out on the balcony, looking at the ocean, hoping some sort of answer would come to me."

"What type of answer did you need? What was the question, Sam?"

"I was looking for assurance from someone, anyone, that I was a decent person, that I had been good to her—I wanted to go on with my life, knowing this about myself."

"Only you could answer that question."

Sam met Lia's gaze. Smiling, he embraced her, holding her closer than he'd ever held anyone before.

12

Clasping Lia in his arms, he was intent on diverting himself, erasing from his mind what had happened a little over a year before.

In Florida he had stayed to himself, had been indifferent to other people circulating about the hotel, had spent one endless day after another on the beach. It had been unusual for him to be this way; it was second nature for him to be aware, to assess his surroundings, those in his vicinity; to an extent he enjoyed and was adept at engaging in light, social conversations.

One afternoon instead of lounging on his balcony or walking alone along the shore, he had gone out to sit on a chair on the wooden deck behind the hotel. There was a sandy area past the deck and the ocean was fifty yards away. He stretched out his legs and dozed off a few minutes later. When he awoke, he noticed a woman reclining in a chair diagonally across from him. She wore huge dark glasses, nearly covering her face, and a large floppy hat. Her hands loosely touched the armrests, she

was in a meditative pose and he wasn't certain if she was awake or asleep. He heard a door open behind him and immediately turned. A man and a young boy holding hands walked onto the deck. They approached the woman, and stood close to her. She didn't look over at either of them, Sam noticed a movement in her shoulders as if she desired to acknowledge them, but was not allowing herself to do so.

The man picked up the little boy, held him tightly to his chest. She didn't turn to them. Sam noticed her raising her hands, moving her fingers as if waving good-bye. A look of anger crossed the man's expression. The child lifted his head from the man's shoulder and began to wail. With the boy in his arms, the man walked away; stopping, he turned to the woman, as if intending to say something to her. He hesitated and shook his head, then left.

Sam understood this woman was in the same state of angst as he was. He longed to speak with her as he would want to converse with a member of his own sex about a shared experience. He was not attracted to this woman, but needed to hear her story. Would it in some way reflect and substantiate his own? He wanted to approach her; he sensed she was empathetic, compassionate, yet there was something quixotic about her as well. He took a deep breath, hoping to transcend his uncertainty, but he was unsuccessful; he was tied to his seat, he could not move.

All he knew was that his life could so easily go in the wrong direction—he no longer had anyone to help center him. Soon the woman rose from her seat and walked past him, her head down.

She was wearing flip flops; her shuffling steps blended with the sound of gentle waters caressing the shore. He was completely subdued; something had been snuffed out within him.

To sustain himself, Sam's reflections turned to his father; he wondered about Jack and his friends in New Hampshire. Was anything transpiring below the surface? Or was it that his father enjoyed the company of men; their interactions were neither emotional nor sexual?

His thoughts shifted to his mother—their love for each other wasn't an engulfing one—how she gave him, her son, space. He knew many people of his age wished to have a mother who was so freeing. But he wasn't the type who desired much freedom—and at times he would consider what it would be like to have a mother who was a little controlling.

13

Lia warmly kissed his lips. Stroking her fine head, Sam asked, his voice low, about her life in Virginia, her family. With a slight drawl, she said, "We are a helter-skelter lot, but we survive," and, looking away from him, smiled bemusedly.

"Helter-skelter, I like that," he answered with a grin. He hoped to learn from Lia.

* * *

On a practical level, they easily focused on their relationship; it was as if they were two pieces to a puzzle with multiple sides that clicked together and became one. Sam applied to MBA programs and Lia became more creative in her teaching, and they married four years later, two weeks after Sam completed his degree.

The wedding was in Richmond. Naomi and Jack drove down from Boston a week earlier, taking a detour through the Shenandoah Valley—Naomi carried a tote bag filled with books.

Jack thought the purple-blue mountainous landscape was nice, pleasant, very pleasant, he would say in his frank, Boston way, firmly crossing his arms, and though he did not openly acknowledge it, he preferred the abrupt and rugged northern New England scenery. Naomi thought Virginians weren't as insistent as Bostonians and she liked that, but then she thought maybe they weren't inclined to be that way because of the warmer climate.

Naomi was reminded of the similarities between Lia and her mother and that pleased her more than she would have realized; for a person who seemed incapable of crying, the thought brought tears to her eyes. For she knew she should have been a better mother to Sam.

It was a great relief to Naomi to hear Sam and Lia exchange vows—she had done the best she could and was comforted by how it had worked out. Jack, on the other hand, was concerned that Sam was not settled enough financially. After Jack's early retirement he had set up a business of his own and had been disappointed when Sam had refused to become part of it. Deeply hurt, he never acknowledged this to his son or to his wife, or his friends; he held it in, smiled graciously, though his discontent was piercing.

14

Eleven years have passed since that rainy May afternoon when Sam and Lia first became a couple. Following their marriage, they threw themselves even more into their work. And so, for the most part, their life has been uneventful. On occasion they have socialized with friends, and they have traveled as much as possible.

* * *

From late May until the week before they left for Edinburgh, Sam and Lia debated canceling their upcoming trip. There were reasons for them wanting to do so, none of which could have been predicted when they had planned the holiday on a restless, snowy weekend the previous January.

Lia's inclination, obstinate but not quite, to almost never change plans, is similar in theory to those who believe it isn't wise to move lanes while driving on a highway. Yet she was

uncertain about traveling to Europe for two reasons—one that she could tell Sam about was that she was exhausted from her work and did not know if it would be better for her to have a relaxing summer; the other one, she could not reveal to him.

The other reason had been set in motion the previous February. It was mid-afternoon; Lia, having returned to her classroom after her students' weekly music lesson, noticed that Ron, the music instructor, did not leave soon after she walked in, as usual. Instead, he stood in the back corner of the classroom, placed his hands loosely in the pockets of his pants, and waited until she dismissed her students for the day. He was very slim, his eyes watchful, and because of his narrow frame, he appeared taller than his actual height.

Once the students had left, he came and sat on Lia's desk, his shoulders hunching forward, his head down. He spoke deliberately of one of her students; he thought her to be quite talented. Lia had regarded Ron as exacting, melancholic, and distantly attractive. She came over, her arms crossed, and directly faced him. He looked up and eyed her, stopped talking for a moment, then suggested they go somewhere else to speak—he had an idea he wanted to discuss with her. Meeting his gaze, she looked at him quizzically.

Suddenly weary, she said, "I haven't had lunch, let's go across the street to the diner."

He shrugged and said, "Fine," his voice now brusque.

Over lunch that day, Ron, gauging Lia's eyes, told her that though he found the student in question to be musically gifted,

he was concerned her parents would not be able to afford voice lessons. Lia felt a quickening in her throat, lowered her gaze and nodded.

After a month of weekly lunches, putting their heads together they came up with the idea of presenting the student with a scholarship. The funding would come from a portion of the money Ron had been collecting from other teachers to improve the cultural life of the community.

Lia had become addicted to her lunches with Ron. Although the problem was solved, their weekly meetings continued. The more Lia went to lunch with Ron, the more she wondered if they were more compatible than she and Sam. She'd listen carefully to Ron's mellow, even voice, bask in his caressing temperament. And she'd often compare his dusky brown eyes to Sam's piercing blue gaze. Because she and her husband were opposites, she needed to be more alert with Sam.

For the last three months of the school year she had been in a state of mild confusion. Also there was her class—this year she had had to spend much of her time coping with a rambunctious group of students.

A little less than a month before they were to leave, she mentioned to Sam the possibility of not going to Europe. On that day it struck Lia in a way it had not before how disappointed she was in herself, in her class, and in her inability to honestly address her attraction to Ron.

"Sam, I am not convinced this summer is a good time for us to travel to Europe." She spoke quietly and honestly, with no

hint of self-preoccupation. They had finished dinner about an hour before, and Sam was perusing the *Wall Street Journal* from his computer. Not certain she had said what he had thought he'd heard, he looked up abruptly.

"Lia, this doesn't sound like you. Did you say what I thought you did? Are you certain?"

"I may be. I've been an elementary teacher for twelve years. The school year will end in two weeks, and the more I think about the year, the more I realize what a dissatisfying experience it has been, and how I have tried to deny it," she said, avoiding his gaze.

He studied her before answering. "Maybe it was just an off year for you, maybe you need a vacation even more," he responded, hoping she would refute what he was saying.

Until this year Lia's approach to teaching had been subtle, quiet; her style with some variations had been quite effective. This class had been the exception. Each year her students had conformed to her graceful method, and no matter the temperament of a student, he or she would comply with Lia's expectations. But this past year her class had been unusually boisterous and she hadn't an inkling why—it seemed that her fourth graders as a group had had a premonition of an exciting event that soon would occur and change the course of their predictable lives. She was dismayed that it had taken her until June to realize the impact of the school year on her students and herself. Lia's natural inclination was to blame herself—maybe she hadn't been focused enough or had not put enough effort into prepara-

tion. Even the students who had closely followed her directions in the first few weeks of the school year had become less compliant by late October—that had been a signal to the others to not change, to remain insouciant. Her solution had been to go along with the class to a degree then change pace when things became out of hand; her whole year had consisted in her teaching in this uneven way, and she had become more and more rattled as the year progressed.

Sam was in the midst of uncertainty in his work as well. Unlike Lia he thrived on confusion; he viewed himself as the anchor in such situations, a role he easily and assuredly assumed. When there was tension in the office, he would become the calming influence. But at this point in his three years at this particular firm, he had become the person to turn to for advice instead of a person of action. And so he realized that in order to rise in the financial world, he needed to make a change or he'd be stuck in a role he did not particularly want.

As Lia was more bothered by her situation and Sam was not at all about his—he welcomed his as a challenge—it was Lia's discomfort that prevailed at this time. For most of their marriage, career concerns had been oriented toward Sam; it was the nature of his work. Now he was fine and gracious about putting the emphasis on Lia. She rarely was dissatisfied.

In the spring they had gone to Maui for ten days. He had had a meeting for work and instead of returning directly afterward, he thought it might be nice for him and Lia to get away. It coincided with her April break.

Once in Hawaii he had noticed that it had taken her more time than usual to relax, but she had not mentioned her work, and Sam hadn't questioned her—for after their third day there she began to slip into the tempo of the island. She dressed in bright-colored sarongs, savored every food she ate, and Sam saw she was becoming physically responsive to the environment—it drew out her innate sensuality.

The moment they stepped on to the plane to return, however, he sensed a change in her, a tightness in her calm expression, a slight downturn in her lips. She neglected to tell him what was on her mind, and he did not ask.

When they got home, she thought she might be pregnant but it turned out to be a false alarm. For the week or so that pregnancy had been a possibility she had been relaxed and had ignored the ups and downs of her classroom. Once she realized she was not having a child she became caught up again with her students, and set up another lunch meeting with Ron.

Lia's need for order was what led her to become a teacher. She was oldest of three sisters, and her mother and father were unfailingly busy, inflexibly so. Her mother was forever in search of the "perfect" career, and her father, who owned his own business, was unaware of his wife's need; he willfully ignored her attempts at trying out different professional paths.

Lia grew up with the knowledge that her family would forever be in a muddle—her two younger sisters and parents from time to time would suggest having a picnic in the woods, or taking a drive on a summer evening after a thunderstorm, or

spending a Sunday at the beach on a particularly hot weekend and these plans would almost never work out. From a relatively young age, Lia was aware how rarely any hastily inspired outing would come to fruition. Despite this, whenever a last-minute plan fell through, in her quiet way, she would be overwhelmed with disappointment.

Several times during her fourteenth year, Lia had approached her mother, asking if they could go to lunch together alone, inwardly hoping it would be the start of organizing the whole family. Lia had always been aware that her mother was the emotional center of the group. Her mother, a slim and decided woman, albeit somewhat disorganized, would smile warmly, and say, "Of course, darling, it is something I would love to do, enjoy a lovely lunch with my oldest, my calmest." She'd pause for a minute and hug Lia. After doing so she'd kindly add, "Let's wait until summer, when things quiet down a bit." At the time Lia's mother was working toward a master's degree in landscape architecture. Following a few non-productive attempts that summer to have lunch alone with her mother, Lia decided to wait it out as patiently and graciously as possible; she began to count the days or, more accurately, years, until she would leave for college and create her own life. In the meanwhile, she turned to her friends.

Her classroom this past term had been a disturbing reminder of her childhood and young adult years, how her family life had progressed in a disorganized way, presenting a chaotic front to their world. And then her unexpected attraction to Ron

had only added to her disquietude. At times she was aware that she might be inwardly conflating the current environment in her classroom as well as those mesmerizing and confusing lunches with Ron to her prior life. Whenever it struck her that she was doing so, she'd brush aside the idea. If she had been more cognizant more of the time, perhaps she would have felt less discouraged and would not have considered canceling her and Sam's upcoming trip to Europe.

* * *

Because Sam understood it was essential for him to find a new job in the next few months and was eager and passionate about doing so, he was also hesitant about traveling to Europe. Given his work, it seemed that it was the right time to make a move. In general, if you stayed on too long with a company, you would be taken advantage of, or worse, would not progress in the field. He believed going to Europe at this time would distract him from his overriding goal of finding the appropriate new job. He felt he had nothing else in his life—other than Lia.

* * *

In the past Lia knew that Sam had not really understood her need to adhere to a project she had begun, or her loyalty to the people she knew. At times it irked her, but she would rationalize and tell herself that it had to do with his work, which entirely

revolved around the ups and downs of the stock market and his ever-changing relationships with clients and colleagues, that it was natural and not difficult for him to reorganize—he was indeed an anchor. And so she would go along with him most of the time, but she never wavered from her need to connect with people or follow through on a plan she had set forth for herself, or for them, until then.

* * *

The day that Sam and Lia met Raine and Ned in the breakfast room in the Edinburgh hotel, they presented a calm front, though within they were struggling. If Raine and Ned had known Lia, they would have noticed a slight tug of concern in her smile that had not been visible before. In Sam they would have seen that his reactions were uncharacteristically firm, not knowing that his natural tendency was to weigh things in his mind before taking action. The change in Sam was because in truth his inclination had been not to travel to Europe. Yet he understood, somewhat begrudgingly, that Lia needed to get away—and so Sam was the one who finally had insisted that they go forward with their travel plans.

Ned and Raine
&
Sam and Lia

The Present

15

Once in Antibes the two couples check in at same hotel and then enjoy dinner at a restaurant close by. Later, they walk by the sea. Although it is quite beautiful, Raine says she has always found it tony, and that the old section of the city has more character. What she read earlier about break-ins has slipped her mind.

In a rented convertible, they drive over to the old part of the city, the balmy night air caressing; Sam, at the wheel, is more relaxed than he's been since they all met, Lia, next to him, is half-turned to face Ned and Raine, who are sitting back, their heads resting against the cushion, their knees parted, holding hands.

After Sam parks the car, they get out and make their way to a nearby café and have drinks. Later, they walk about for a while. Soon, they all agree that they need to rest. They find a small square with two benches. Exhausted from the train ride, the rich dinner, the wine and liquor, the long walk and sea air, they collapse onto the wooden seats—Ned and Raine on one

bench, and, across from them, Sam and Lia on the other; within minutes they are all asleep.

It is one o'clock in the morning. The moon, low, deeply cratered against the still black sky, evokes conflicting impressions of both permanence and mystery. The paint on each bench is chipped and the palm plants bordering the concrete square haven't been attended to in months. The surrounding silence echoes the starkly complicated presence of the moon. It is unusual that they, Americans, in their thirties, have fallen asleep on park benches, in the early morning hours, in a foreign city. Unusual because each of them is considered to be mature, responsible, and marginally cautious under certain circumstances, which, depending on the individual, differs.

Moonlight grazes Raine's olive complexion and elfin features. She is stretched across Ned's lap, her face in sleep points upward, her chin propped up by her husband's knee, her expression yearning. Her dreams are vague and amorphous; she longs to hold on to an image but is unable to do so. A revolving sensuality, bordering on raw sexuality, followed by a whirling confusion each in turn prevail, as if she is on a merry-go-round and cannot touch or fully see a passing horse. For she is unable to grasp or clearly visualize any one of the repeated and revolving forms or shapes in her dream; consequently she is denied any sense of discovery or resolution.

Ned sits languidly, his head to the side, his shoulders slouching against the back of the bench. He's sleeping not quite soundly, his legs spreading, the warmth of his wife's body

across his lap both comforting and disturbing; he feels encouraged by her presence, the pressure from her chest and long torso, but he is less free to move. He is in the midst of a recurring dream, one that he relishes. Once he awakens, he will experience, as he invariably does, a sense of renewed strength. There are elements of reality in his dream before it abruptly turns to fantasy; in fact, his mother was a cabaret singer in Chicago. And though she had moved to Boston with his father years before Ned was born, she and her husband often visited Chicago with their sons. On one trip she had taken her younger son to the venue where she had performed. Neither his father nor his older brother, nearly ten years Ned's senior, had accompanied them on this visit. In his dream, a twelve-year-old Ned is stealthily walking into a darkened room. He eyes a small round stage at the front, which he finds enticing, and is infused with a stirring sense of warmth. Moments later he realizes the room is smoke-filled and dense with people. He is overwhelmed and alarmed; it is unlike anything he's experienced before. In his dream his mother is on stage singing, though he has never heard or seen her perform in public. In the middle of a song she stops, her eyes sparkling; extending one arm, she calls for Ned to join her on stage, her hands beckoning, her long, tapered fingernails bathed in a bright red polish. Frightened, he turns away, runs toward the exit, which he cannot see because of the rising smoke; he crashes into tables, causing drinks to spill, empty seats to fall over. He is no longer a sedate young boy, but a menace. Awakening, Ned is not disturbed by the ending of his

dream, which he recalls in vivid detail; instead he is comforted that he still has a dream that springs from his childhood. Cathartic, he thinks, with an ironic smile, before falling back to sleep.

16

The moonlight in Antibes neither surrounds nor touches Sam. He sits erectly on the bench, pressing his tightly crossed arms against his broad chest; he sleeps deeply, and his expression is blank as if he is experiencing no sensation or emotion. Mostly covered by darkness, he will not remember his dreams when he awakens; they will wash across him like a cold shower, invigorating him. It does not bother Sam that he doesn't remember the images that have passed through his mind over the course of the night. It isn't necessary. He acknowledges that everyone dreams and to this point he hasn't been interested in knowing why he doesn't recall his own. All he concludes is that they prompt him to take action, for he invariably feels confident in the morning and productive during the day, and this in itself quells any curiosity he might have about the content of his dreams.

Whereas Sam to a significant degree is submerged in darkness, in contrast, Lia, next to him, is in the light; the moon's

rays focus primarily on her. Her dream is of fleeting images, not intrusive, but cheerful, more so than you would expect when looking at her when she is not sleeping, her reserve, her precise manner. In her dreams, she is uninhibited.

* * *

Raine's dream gradually becomes more and more clear, less and less swirling. She's grasping a gold doorknob; close behind her, she feels Ned's presence. Another figure stands with his arms crossed on the other side of the room. She can't quite make him out. She awakens from the shock of who it might be, what might have happened. She lifts herself up from Ned's lap, stands up, and paces. After a while, still agitated, she stops and sits next to her husband. She wants to shake him from his sleep, tell him she feels as if she's choking. But she doesn't.

Twenty minutes later, the group is roused by what sound like cries from a small animal gasping for breath. They look about and in the fog of their hazily aware state, they gradually realize there are only three of them—one is missing.

17

It is Sam who first registers that someone is missing and which one of them it is; the most awake, he stands up abruptly and crosses his arms. His breaths are quick and his eyebrows tightly raised. With a degree of angst in his voice, he leans in close to Ned, assures him that they will find Raine. Ned, not appearing to comprehend—he is not fully awake—remains on the bench and shrugs, seemingly unaware that his wife is missing. Sam and Lia surmise that Ned believes he is in the middle of a dream. No longer do they hear the crying sound of the small animal gasping for breath, wondering if it came from within.

Lia touches his arm and says, "Don't worry, Ned. Raine must have gone to look for a restroom. There is a hotel close by." But her tone suggests she isn't convinced of what she is saying.

Although Sam is ready to take charge of the situation, his obvious concern is shifting to a growing annoyance—he had hoped things would go smoothly on this trip, and half suspects that Raine wanted this to happen, that she had planned to

disappear, or at least worry them in one way or another. He recalls her expression on the train when she told him about a wave of break-ins in Antibes. It seemed to pique her curiosity.

Now that Ned is more awake, Sam senses it is dawning on him that Raine is missing. Ned nods in sleepy agreement with what Lia has said.

Sam wants to believe that Raine has left to find a restroom, yet he knows that neither Lia nor he are certain of it. One does not disappear and go in search of a restroom in the early morning hours in the old section of Antibes, France, without informing someone first, asking one of them to accompany her. It is not thoughtful to wander away on your own in this situation; it is not sane. Yet he has had questions about Raine since meeting her—he's found her edgy and distant on the whole and intrusive when least expected.

Sam suggests they all go to the hotel Lia mentioned to see if Raine is there. But Ned refuses to get up from the bench—he is convinced Raine will return and wants to be there when she does. She knows how to take care of herself, she is pretty independent, he says and smiles. He does not appear worried. Sam and Lia eye each other, wondering if Ned is in a state of shock.

"Why did we not follow our original plan as we invariably do and go to Burgundy instead of Antibes?" Lia asks herself, knowing full well their decision to go with Raine and Ned to Antibes has nothing to do with the movie that was filmed on the Riviera. She lowers her head and ponders: "Why did Raine leave Ned to wander away in the early morning hours in another country?"

Ned and Raine

18

Twelve years earlier, spotting Raine Delone on a Florida beach, Ned Lanier experienced a sense of catharsis. Wading in shallow waters close to the shore, he looked up and noticed a woman chasing after a young boy; her expression fixed, yet there was something lost about her, how she moved across the hot, thick sands. He was struck by her lean, medium bone structure, her dark hair, and her small visage. To Ned, her sudden appearance was out of context, as a character would be in an unevenly edited movie. The young boy wanted to escape her grasp but Ned wasn't certain if the child was teasing her or truly didn't like her. Either possibility intrigued him. He stood still and watched, the water now covering his ankles; he intended to help if she needed it. Soon she caught up with the young boy, hastily picked him up and carried him away; in her arms, the child squirming, the woman's expression never changed. Ned wondered what she thought of the boy, guessing it was not her son; the child was blond and pudgy.

* * *

Whenever they were asked how they had come to know each other, Raine and Ned would say they had met unexpectedly; neither had been, for various reasons, interested in a relationship at the time. They had refrained from acknowledging it openly, even to each other—though it was understood between them—that it had been the most uncertain of periods in both their lives, when they each had begun to question their beliefs, their identities.

They wanted to convey to the person who had asked that the circumstance in which they met was not romantic but surreal. They would neglect to say that Ned had escaped from Boston because of his father's interference in his work and that Raine had been vacationing in Florida with a man to whom she was engaged. His name was Lee.

Lee was fifteen years older than Raine. Just out of college, she had been hired as a freelance commercial artist for a specific project at the advertising firm in New York where Lee worked. They had met at an office party; both had been lingering close to the spiked punch bowl.

After conversing for twenty minutes or so, they wandered away from the gathering and soon Lee was opening his car door for her. With an intent expression in his eyes, he drove her to his condominium. It was on the fortieth floor. Upon entering his apartment, they began to make love in the foyer.

When Raine woke the next morning, she was somewhat stunned—nothing like this had happened to her before; she had

always been particular about the men she had slept with and in truth there had been only a few. As she was trying to determine what had come over her, Lee walked into the room in a plush green robe and handed her a cup of coffee.

She was more surprised and puzzled when, after she had one sip, he took the cup from her, placed it on the table next to the bed, and began making love to her again. At the time she had had no idea of his age—she knew he might be a few years older, but would not have guessed fifteen.

Raine soon discovered that Lee had been married before and had a four-year-old son. She was introduced to his son two weeks after their first encounter. Lee had been anxious for them to meet. Though he would not acknowledge it to her or himself, it was a test to see if the three of them would fit together.

He was extremely fond of Tyler; in fact, he had never loved anyone more. He had found his first wife interesting and highly intelligent, cool, and caring in a practical way, much like his parents had been to him.

Lee planned to have her meet his son at an ice cream shop in Greenwich Village—he hoped Tyler's appreciation of ice cream would be transferred to Raine.

On the specified day and time, Lee and Tyler walked into the ice cream shop hand in hand. Raine was sitting at a table in the far corner, her arms and legs crossed, looking toward the window, waiting for them. Fleetingly it struck Lee that in profile Raine resembled images he'd seen of Nefertiti.

The moment Tyler realized they would be sitting with Raine,

he cried out for his mother. His cries were insistent and panicked. Halfheartedly Raine attempted to console the boy; she was not fond of young children because she was uneasy in their presence.

If it hadn't been for Raine's attraction to Lee and her belief that he was the love of her life, she would have stood up and walked away five minutes after the introduction. Since she wanted her relationship with Lee to continue, she needed to appreciate the child, appeal to him in some way.

While Tyler continued to cry for his mother, Raine, with nervous intensity, began to draw a picture for him on a napkin. She knew that Lee recently had taken Tyler to Disney World. Soon Raine inclined her head toward the child and asked in her detached but kind way who he thought it was. He immediately looked away; he regarded her as the enemy. But eventually his curiosity got the better of him and he turned round, stared at Raine's drawing, put his finger on it, and said it was Mickey Mouse. He looked at Raine quizzically and she nodded affirmatively, his father assuredly patting his son's back. Tyler tried to smile but could not do so, yet he was beginning to comprehend that maybe she wasn't that strange after all. Then Raine drew Donald Duck. She wasn't particularly warm toward the young boy but her drawings were spirited and hopeful. As long as she was drawing, he accepted her.

Lee was pleased and thought that, along with ice cream, now his son could make the connection between Raine and his favorite cartoon characters. He wasn't surprised as he had been

drawn to Raine for the same reason—he had seen her sketches for the advertising campaign he was working on and had wanted to meet the person who had done them. He had been told that her name was Raine and that she would be at the office party that night. As Lee ladled more punch into his cup, they began to speak; when she told him her name, her sketches had come to mind.

Now Lee felt assured; his guilt at leaving his son's mother was mildly assuaged. They were married young and, having been consumed by their careers, had waited to have a child. When they began to wonder whether or not they should separate, his ex-wife discovered she was pregnant. Her pregnancy and Tyler's birth had strengthened their marriage for eighteen months or so, but soon their life returned to how it had been before.

Now that Lee was in love with Raine, and his son's mother was involved in another relationship, he and his ex-wife were at last becoming friends.

19

When Raine's mother, Dania—a curvy woman with dark arching brows and a fixed gaze—became aware of the age difference between Raine and Lee, she decided she would have an honest talk with her daughter.

It was a misty Saturday morning in early November and Raine and her mother were walking to Dania's favorite neighborhood café in Cambridge. In her direct way, she turned to her daughter and in a voice that was slightly pressured, she said she must speak the truth—that she believed that Raine was looking for a father figure. "Your father passed when you were young; you never knew him. He was complex," she said, her tone thoughtful, though there was a staccato quality to her presentation. Raine listened to Dania's words. Not as prone to introspective as her mother, she responded by saying that her father had been much more than fifteen years older than she was. She attempted to conjure images of her father walking up the front steps of their home, of him holding her in his lap, or of herself hiding beneath

his desk. They were not real images but recollections of photos she had seen years ago, and which may have been lost when the family moved cross country. For she doesn't have any actual memories of her father.

Raine's mother again said that she believed with her whole heart that Raine was looking for a father figure.

Raine easily ignored her mother's advice—she considered herself independent from Dania's overall view of life. She enjoyed Lee's company not because he was a father figure but because she liked to discuss things with him—he seemed to appreciate her drawings and would listen closely to her opinions on a variety of issues.

Two and a half months after her conversation with Dania, one night, during a vacation in Florida, Raine wondered if her mother might not be wrong. She and Lee, now engaged, had just made love and she had been disappointed; he had seemed at a distance from her.

He got out of bed abruptly, and Raine saw that his forehead was wet from perspiration. Soon he was standing close, putting on his robe, wrapping the belt tightly around his waist.

His voice terse, he suggested they sit out on the balcony, that he'd make drinks. She got up and put on a robe, but it continued to bother her how distant he had seemed and again she tried to discern what was disturbing him, if anything. She recalled the details of the day, thinking it had been quite fine; they had spent some time on the beach, and later had gone to the pool with Tyler. She recalled that Lee had received a call

after dinner, and though his communication with her had not changed directly after his phone conversation, she had been unsettled by his love-making.

Raine and Lee sat back in their chairs. It was a little after eleven; there was a late-night breeze and the sound of waves breaking against the shore was calming. In the next room, Tyler slept soundly.

"Raine," Lee said in a hoarse whisper. She looked over at him; his face was covered in darkness, and all she could make out was the expression of fear in his eyes. He seemed different, almost a stranger. He cleared his throat and between sips of Jack Daniels, he said that he had thought a great deal about them as a couple and was convinced that if they married, it would be a failure. Mainly it was because she was not affectionate enough toward his son—she was, at best, disinterested.

Shaken by his words, Raine acknowledged to herself that he was speaking the truth; she had honestly attempted to like the boy, but the reality was she had never been inclined to think about children very much, simply believed that one day she would have one or two. And the idea of giving birth and raising a child had seemed so far in the future that she had not been inclined to connect with the young boy.

"I don't think it is wise to give up on the relationship so easily. I have not yet learned to really appreciate any child, but it will come in time, Lee," she said. She spoke directly and clearly but felt emotion creeping up within her and heard a tinge of uncertainty in her voice. "You may be afraid of having another

failed marriage, it may be what is behind your need to break off our relationship," she said, now angry with him, comprehending that he was weak, having had an inkling of this on several occasions, but she had brushed off this concern, had not wanted to believe it was real.

* * *

An hour and a half later, after they had hashed everything out—she was exhausted from their intense discussion, her emotions were swirling—she began to pack her clothing. When she looked up, she noticed that Lee had left his phone on the bureau. She went over to it and saw that the last call had been from his ex-wife. Raine placed the phone back on the bureau, upset though pleased she had discovered the true reason for Lee's breaking their engagement. Was he a coward or an unselfish parent? She did not know and at that moment, she did not care. She felt he should not have made love to her that night—he should have been truthful. Yet she was not particularly fond of his son; she could not deny that.

* * *

The same night and into the early morning hours Ned had been working as a clerk in a southwest Florida hotel, having left his job with a newspaper in Boston. His father, a prominent lawyer in the city, had firmly disagreed with the political views he

believed his son was espousing in his weekly articles, and had threatened to interfere with Ned's work—he was friends with the publisher. Ned, one of those rare unbiased journalists, thought his father was reading a perspective that obviously was not there. He was known for his objectivity, never taking a side, simply reporting facts. Inwardly appalled by his father's response, Ned had kept his calm and had reached out instead to his mother, explaining how he attempted to always bring in both sides whenever he wrote about politics. She said she understood that about Ned, agreed that his articles did not reveal a political bias. After lighting a cigarette, she told Ned that people are not always that open-minded and some tend to be parochial when it comes to politics, read into things, and that it could affect his father's work, the firm was not too happy with one of its partners having a son who was a political journalist. His father was under pressure—she seemed worried about it. Briefly Ned wondered if she was worried about their marriage not surviving the situation, comprehending that she was only being truthful. After this conversation, Ned realized his father was serious, that he had to be for his own survival.

Angry and disillusioned, Ned decided he needed to get away. He chose to travel to Florida to avoid the winter. He went to the southwestern part of the state. There were few New Englanders living there through the cold months; most were from the midwest. He found a part-time job working the night shift at a hotel. He would continue to do so until he found a job with a newspaper in the area.

* * *

Raine, following the painful breakup of her engagement, left the condo where she had been staying with her now ex-fiancé and his son. It was after one in the morning and though Lee had begged her to not leave until the next day—he had offered to sleep on the couch, his hands clasped together as if in prayer— she walked past him, ignoring his pleas, out the door, down the street, and wandered into a nearby hotel. She had thought it best to wait a few days, collect herself before flying back to the northeast and facing questions from her friends and her inquisitive mother.

Upon seeing Ned at the front desk, as tired as she was, she was taken aback and for a moment forgot how distraught she was. She eyed him; his hair was disheveled, the collar of his polo shirt frayed, and despite his unkempt appearance, he had spoken kindly and thoughtfully when checking her into the hotel, meeting her gaze in what she would learn was his warm and dispassionate manner. Ned, who was lanky and stood a quarter of an inch over six feet, was the antithesis of Lee; Raine found his presence reassuring.

Yet it would be another ten days before they would get to know each other. Raine stayed in her room for the most part; she only left to get something to eat. She'd walk with her head down; she didn't want to be noticed by anyone or recognized. She wasn't certain who or what exactly she was hiding from but she knew she must hide. She had been shamed by her relationship with

Lee—she had hated to admit that her mother had been right. Her only desire now was to escape, become another person, a person she'd never been before. She supposed she had always wanted to be noticed on one level or another, that was part of who she'd been, but now she longed to step into another role to shed the embarrassment she was experiencing. She wore clothes she'd never think of donning before; rarely talked to anyone, no longer seemed to possess the avid curiosity she'd always had about other people. It wasn't only that she had lost Lee; the bigger loss was that in her relationship with him she'd lost confidence in her judgment.

* * *

Two years later, Ned and Raine eloped, and told their respective families the following day. Ned's mother answered the phone as she often did. He and his father had always been uneasy conversing with each other, especially over the phone. His mother was happy; she had never heard her son sound this assured and that buoyed her as well. She'd always thought he possessed a great capacity for happiness. She paused for a moment, appreciating the news, then said as an afterthought that she believed his father would be pleased as well.

After a five-year stint as a journalist in Tampa, Ned and Raine returned to Boston, where he, with the same newspaper as before, reported solely on international issues.

20

Dania, Raine's mother, driving toward her yoga class, heard a chirpy sound coming from her cell. She held up one soft round hand as if cupping a golf ball, but she didn't pick up the phone; she had a premonition it was from Raine and experienced a fleeting sense of dread as she often did when it came to her middle child. She believed the news would not be what she was hoping to hear, that she would be disappointed. She took a right off the main road, parked her car on a small street and, while taking deep breaths, she listened to the recording of her daughter's throaty voice revealing that she and Ned were now married. Dania put down the phone, then inhaled and exhaled.

Although Dania was not opposed to a marriage between her daughter and Ned—she found him steady and thoughtful—she had aspirations for Raine. She had been hoping her daughter would have been more settled in her career before marrying. Of her three children, Raine was most like her late husband, the same slim visage, the same intensity and grace. Her middle

child's resemblance to her father aroused conflicting feelings within Dania.

Dania thought more about Raine than she did about her other two offspring; her second child was the most enigmatic of the three. Raine's mind often seemed to wander off, and Dania reasoned that if she became immersed in her profession, it might help center her. Dania's tendency was to be forward-looking; this approach had gotten her through difficult times. And she did appreciate Ned as much as she was able to like anyone who was close to Raine. Sitting in her car on the quiet street, she paused for a moment and sighed, accepting Raine's decision to marry Ned.

Dania put her cell phone in her pocketbook, started up the engine, and thought about her relationship with Edward Delone; they had married three months after they had met. She had been swept off her feet, which, in retrospect, she found ironic as before meeting him she had not believed this was a possibility—she thought the whole idea sounded like a fairytale; she'd always been wedded to reality.

The oldest of four children, Dania had grown up in the academic haven of Cambridge, Massachusetts, where her parents owned a small but amply filled variety store on Harvard Street. Dania worked in her mother and father's store in the late afternoons and early evenings throughout high school and college.

On a chilly April day, Edward Delone walked into her parents' store. He hesitated at the door and looked around before entering. Having come in to ask for directions, he said he was

not from the area, but from the west coast, and said he felt like a fish out of water in Boston. His voice was calm, his gaze sharp. He and Dania were about the same height, but because he was slight, he appeared smaller than her.

"California?" Dania asked with a hint of smugness in her voice. Nodding, he met her gaze for the first time. She thought she caught the beginning of a smile crossing his mouth but wasn't certain. His lips were thinner than she liked, and though she could see that he had shaved that morning, his face was a little bristly. In a way, she overpowered him, she thought. He seemed quiet, slow moving, with a male gracefulness. Along with a sharpness, there was also a thoughtfulness in his pale green eyes, which intrigued her; his gaze taking in the variety of cigarettes and cigars on the shelves behind the counter.

He was looking for a particular hotel in Harvard Square, he said, his words measured. He wore a light raincoat. She imagined he must have heard that New England springs were nice, but she found April, in general, to be an unsettling month; it had everything, rain, wind, both cold and warm temperatures, and dampness, even on occasion a possible light snow in the early days of the month.

It was the middle of April, too windy and damp to feel like spring. "It's close by," she said in her practical way and easily gave him directions. If the hotel had been farther away, even in an adjoining town or city, and the instructions more complicated, she would have spoken with the same ease; she was oriented that way, having a good sense of space and location. The hotel

was not very far from her family's store. It was a stodgy sort of hotel with a brick front; it must have been suggested to him by someone who knew the area or was familiar with his taste, she assumed.

After she gave him the directions, he left abruptly and Dania shrugged. She had not considered him attractive; he was too slim for her.

She did not think of him again, though she would later say she might have had a dream about Edward that night, it was always a possibility. She believed she possessed a strong intuitive sense and in retrospect it had disturbed her that once he had left the store she had not consciously thought about him until he came by again five days later.

Her strong reaction to seeing him the second time was what revealed to her that she liked him more than she had thought. Upon seeing Edward, she was startled and nearly dropped a package of cigarettes she was about to hand to a customer.

"Hi there," she said, sounding surprisingly calm. "On your way back to California?" she asked, feeling an attraction she'd never before experienced. Usually she was assured, practical in her interactions with men. But this one was different; he was a mystery to her.

Dania did not differentiate between Los Angeles or San Francisco—to her California was one big plot of land she'd see on a map, no definition, no character; yet at the same time it piqued her curiosity. To her, Edward represented all the elements unknown to her in the state of California.

"My plane is leaving early tomorrow morning. Maybe we could walk into Harvard Square once you are finished for the evening?" His voice was even, his gaze avoiding hers; for a moment she wondered if he were inviting her or someone off to the side. But when he finished speaking he looked directly at her. She easily smiled, then nodded, and told him to wait outside; she'd be with him in ten minutes.

She placed a call to her mother—her family lived on the second and third floors above the store—and told her she had a date that evening, and could she come and cover for her at the store? Always wanting to please Dania, her mother responded that she'd be down in five minutes.

While dining at a restaurant on the top floor of a large hotel with a view of the Charles River, Edward asked Dania, "Do you like it here?" She looked out the window and saw the city lights reflected in the river and felt a touch of familiarity mingled with an aura of hope, replaced by a sense of smallness, a lack of expansiveness; she knew there was more. But she assumed he was referring to the restaurant.

"It's a very nice restaurant. I'd heard it would be opening, didn't realize it already had."

"Glad you like it," he said with a swift smile, appreciating her frankness, which was what drew him to her. He found it fresh and unaffected, like her flat and nasally Boston accent. "I was thinking of the area, this state, this part of the country. Would you ever want to live somewhere else?"

"I know of no other place. I've always lived here. I have

nothing to compare it to, and so I can't answer your question." She looked at him querulously; she had taken his question much too literally, she soon realized, though she herself had hoped otherwise. Needing to overcome her New England caution, she paused for a moment, looked down, but when she raised her head she smiled, and said, "Oh, I see what you mean."

Dania visited him in California a month later, two days after she graduated from nursing school. Her purposefulness in finishing her classes had diverted her from focusing on her upcoming trip the west coast. She had lost some weight, which made her look more exotic. Her concern was that it would be disappointing to see him, that the chemistry between them would not be the same as it had been those rainy April days; he had stayed in Cambridge a week longer.

But her worry had been unnecessary. He was more relaxed in San Francisco, more forthcoming, less hesitant, more appealing. When he picked her up at the airport they fell into an embrace. She felt the pressure of his arms round her—realizing how much stronger he was than her; she had forgotten.

She loved the city—there was something freeing about San Francisco; the sky was incredibly blue and the ocean was breathtaking. She was pleased with his apartment—it seemed to be a microcosm of the city itself, open, blue and spacious, but most importantly, she loved him inside it—it suited him. She understood who he was; she was captivated as he explained how he had come upon one piece of furniture or another or had found a painting that he liked and had bargained for it at an auction.

And then there were the many sculptures he had collected—mostly from Europe, he said, handing her his favorite, a wooden carving of a Tyrolean woman in peasant garb.

Dania enjoyed walking up and down the hilly streets, and easily fell in love with the Pacific Ocean. "So much broader than the Atlantic, it seems; San Francisco is so open, so wide, so welcoming," she said the night before she left, her eyes filling with tears.

He drew her close and said, "Just like you, Dania. Stay, don't go back."

"I must leave. I'm starting a new job in a few weeks. I'm looking forward to it." As she spoke it struck her that no one before had been this direct with her—most others seemed fearful of her, her reactions.

"Why don't you see if you can find a nursing job out here?" They were about to walk into the movie theater when he slipped this out. She was caught off guard; she had not expected him to ask her to stay. Throughout the movie, Dania thought about it, and though she had not known him very long she believed she knew him better than she had known anyone else. She attributed it to falling in love, thinking that this is what it is all about. But it was causing her to make quick decisions, something she'd never been inclined to do before. She'd always been even-keeled and though spontaneous she had been able to maintain her balance. This is what she held on to, what helped her decide.

* * *

She and Edward named their second child Raine; she had been born in the midst of an unexpected San Francisco storm; Dania had insisted on adding an *e* because to her it represented the energy of the emerging sun after the rain. She'd often point this out to her daughter. And Raine would notice that whenever her mother sent a card to her, she'd write the letter *e* at the end of her name, the bottom of the letter curving upward like the upward curve of Dania's flip hairdo, which she'd never change, whether or not it was in style. Because of Dania's determined nature, she had been able to go on with her life after her husband's early death; she had been an example to her children.

Throughout the years, Dania has thought a good deal about her second child—feelings of guilt commingled with concerns about Raine. Has her daughter truly found herself? And Dania's view of Raine has not wavered: she is both puzzled and worried about her daughter, almost obsessively so. In moments of deep insight and inner clarity, she knows her middle child is more affected by the past than she, Dania, has believed; she is convinced Raine's awareness, though perhaps nebulous, may lead her daughter astray.

Ned, Raine, Sam, Lia

The Present

21

Alone now, while Sam and Lia have gone to search for Raine, Ned remains on a bench in the park; he eyes the concrete walkway before him, the yellow-green palm plants on the periphery. His legs outstretched, he uncrosses his ankles, spreads apart his knees, and leans forward as if about to pounce. His expression is surprisingly mild, milky. A light breeze running down then up his arms ruffles the short sleeves of his shirt. Reaching out, he touches the part of the bench where Raine sat less than thirty minutes ago—it's rough against the palm of his hand, the texture like sandpaper he may as well be rubbing against his chest, his face.

Not long before, her wiry body lay sprawled across his lap; in a deep sleep, the weight of her medium form pressed his legs against the wooden slats, transporting him to another time, another bench. *Too young to know the difference—right and wrong. A stronger child punching both his legs until he falls, his forehead hits the dirt. His cries are soft. He turns his face to the side,*

catches sight of the mothers, his and the other child's, sitting on a park bench across from him, chatting away in a halo of sunlight; unaware of what he is experiencing, they are enclosed in the aura of their adult world, a bubble he longs to prick, but he is unable to because of his age, his temperament. Grownups are untouchable, unlike children, he gleans.

As an adult, people like to reach out and prick the bubble he lives in; it happens so often he believes he no longer exists in one and he's naked to the world. It's because he appears easy, pleasant, balanced, he concludes; it's natural for others to want to upset his equilibrium, his world, to leave him bare. He thinks of his father's attempts to prevent him from doing what he does, being who he is, forever warning him about the pitfalls of expressing his opinions—no matter how unbiased he believes they are—in print.

Now his wife's sudden absence in a foreign place exposes him even more than before. Yes, Raine's no longer with him, no longer present, no longer in his presence, he tells himself, struggling to adjust to this reality. He cocks his ear—is that her laughter in the distance, throaty and warm? He imagines her turning away from him as she does whenever she's preoccupied with something, with someone else; she is like a dark-haired ballerina, twirling away, a subject in a Degas painting, the same narrow face as the dancer, the same strong and flexible physique. "I need to look for the sketch I was working on last week, Ned," she'll say, her voice only mildly pleading, somewhat teasing, not wanting to offend him. "Those brown eyes of yours—

soulful and too distant—unusual." Her voice will have a pungency to it. She'll tilt her head to the side, her pale green gaze assessing him. "Later," she'll add suggestively—then she'll smile. He'll wave her off. He likes when she leaves as much as when she stays; her presence lingers like a musky perfume that is more seductive once it has settled in than at first spray. Yet in another country, in another world, her absence is discomforting.

Although he and Raine have been to the old section of Antibes before, there is an unfamiliarity about this place. An aura of unpleasant mysteries prevails. He regards it as a place for people who in one way or another have lost themselves. He recalls the article he read on the train ride down from Paris, about recent break-ins at hotels, in this part of the city. But he refrained from saying a word about it to the others; he didn't want to spoil the trip.

When she persuaded Sam and Lia to accompany them to Antibes, he thought it would be fine, but now he only desires to be alone with Raine in a town, a city, a country that he knows, where he is known. These thoughts cause his hopes to rise and he tells himself she will return soon, yet on another level he is more uncertain that she ever again will be in his presence.

There were those years when he was without Raine, when he was Raine-less. At times he was happy, at others melancholic; he had felt marginally complete, shakily so. But when he met Raine he became another Ned, a more whole person, a more wistful, more content human being than before.

He thinks of Sam and Lia, a couple they knew nothing of

ten days before; he envisions them making their way in the dark, searching for his wife. His inclination was to stay, to wait for Raine. Lia had eyed him steadily, a brief, worried look crossing her placid expression. But she was no longer calm, accepting; it was how she pursed her lips—yes, her concern was in her mouth, the rest of her remained steady. And he felt Sam's subtle restlessness—but Sam, brilliant and brawny, had appeared this way from the start—not wanting to be in Europe? Not wanting to have gone to Antibes, would have preferred to have kept to their original plan of going to Burgundy? Not wanting to be with him and Raine? Not wanting to be with Lia? He tosses this thought aside—why would Sam not want to be with Lia—she is what holds him together, isn't she? That is how it appears at least. From time to time he's noticed her touching her husband's arm as if to calm him down, but to Ned, Sam never appeared riled, only restless, mildly so. He views Sam as unflappable.

They told him to wait, that they would check to see if Raine had gone to the hotel nearby, only a five- to ten-minute walk away. They had their cell phones with them and asked if he'd text to let them know if she showed up, reminding him that over dinner Raine had mentioned that she'd left her phone at the hotel. He'd forgotten. Though now he recalled eyeing her phone on the bureau just as he was closing the door of their room, and how he'd made a quick decision not to tell Raine.

He nodded and as they began to walk away he called out their names, raised his hand, and said, "No worries, she'll be fine," his voice easy, though higher than usual, his posture re-

laxed; within he was raging with anxiety. He's always believed you never reveal how panicked you are.

Sam and Lia stopped and gazed at each other before turning to him; they said they would not be long. As he watched them leave the park, he noticed the weary fall of Lia's shoulders and how Sam assessed the surroundings alertly, earnestly. Ned has concluded Sam is nicer than he wants to appear. He is more than what he seems.

Despite his extreme unease, he tries to convince himself he is overreacting, that most likely there is an explanation of one sort or another.

He considers calling Dania, Raine's mother. It must be 8 p.m. on the east coast of the United States. He takes his phone from his pocket, imagines his mother-in-law's smile, her hearty laugh, those often and sudden instances of worry in her eyes, and then he abruptly puts his cell away.

The first time he met Dania wasn't she in the middle of something? He had only known Raine for a few months and they had come to Cambridge; Raine needed to pick up some of her belongings. Although it was spring he'd felt a chill in the air. They were walking down the main street where Dania lived. Raine was talking in a more agitated voice than usual, her words were clipped. He knew she was anxious about his meeting Dania and he guessed that Raine's mother might be a dominating person. Raine had told him that her mother had not at all liked her previous boyfriend, the man she'd been engaged to—had called him a father figure.

Ned had responded by saying that her mother could not say that about him. Weren't he and Raine only a few months apart?

They approached her mother's home; Dania had had it converted from a triple decker into a one-family. She was very good at arranging those sorts of things, Raine had said—mostly because it kept her busy. If her father had lived, Raine said, she didn't think her mother would have occupied herself in this way—she probably would have gone back to nursing.

They rang the bell and stood on the front porch, waiting for the door to open. Raine had left her key in Florida. They looked at each other and Raine began to pace, her arms crossed; he could see a shiver run across her back. He followed her pacing with his eyes, and then with his feet. When he caught up with her, he rested his hand on her shoulder; she stopped and turned round to face him. Raine's gaze locked onto his, and he'd been reassured.

Hearing the door creak open, they turned to see Dania standing out on the porch, without a coat or jacket. She looked wide-eyed and dismayed at first, then flashed a warm, engaging smile. She came up to them, threw her arms around Raine, then him. Ned remembers her warm flesh, her bright smile, the gleam in her eyes—yes, Dania. She said the doorbell was not working and she had just come out to check the mail. She had been in the middle of making out her grocery list for their dinner that night—she'd been so looking forward to seeing them, to meeting Ned. Dania had charmed Ned and had never stopped doing so.

But maybe he's misunderstood Dania, maybe she isn't so accepting of him, of them as a couple.

He looks up at the sky, spots a streak of light and feels happier, but then recalls Raine and Sam on the train from Paris to Antibes, sitting next to each other, talking in an intense and too familiar way—the same way Ned's thoughts flow when he is without her. It's as if someone is piercing him with a sharp blade, and he fights through the pain, not knowing who is holding the knife.

His phone signals that a text has come in. He pauses before reading it—a balmy breeze crosses his forehead; deep within he grasps she's alive and he'll remain enduringly lost in Raine.

22

Not familiar with the road, it will take Sam and Lia fifteen minutes to reach the hotel. Still awakening from their sleep, they step in what they believe is the right direction. Overall, Lia's pace is more cautious than her husband's; at one moment she'll walk as swiftly as Sam but at other times her steps are even slower than they normally are. She goes back and forth between these two gaits.

She shakes her head and tells Sam it isn't wise to have left Ned behind. "He is in no condition to be on his own; he's in a state of disbelief," she says. Again she shakes her head. She feels she is not being heard, her voice echoing back to her in the darkness as if there is no weight to it, no significance. Sam, walking a few steps ahead, barely catches what she is saying—not only is her voice soft but he doesn't want to be distracted by words; he is completely focused on finding Raine and then getting on with their trip. His goal is to extricate himself and Lia from this situation. Obviously, finding Raine is the crux of this situation—

and he knows from experience that once the crux of a situation is addressed everything else will fall into place. He needs even more than Lia does for things to fall into place.

Although he desires to separate from Ned and Raine once the situation is solved, he wonders if Lia will want to do so, if she might prefer to stay, to submerge herself in their confusion; he understands that she is attracted to their personalities on one level while on another she does not want to be. This worries him. He gleans there is something unhealthy about Ned and Raine as a couple and he can't quite put his finger on what it is. And he is puzzled why Lia has accepted a change of plans, so unlike her.

With purpose, Lia is walking more slowly; with every step she considers turning back to get Ned, to convince him to come along. In a way he is like a child to her. He is innocent—something she has never been but has longed to be. Raine too is innocent in her own way, not as innocent as Ned, she thinks, yet more of a purist than she, Lia, is.

Sam calls out to her, points to the hotel; it is across the road, facing them. Lia quickens her pace and grasps Sam by the hand. She feels lighter now, forgets about Ned sitting alone on the bench in the small park.

Clutching each other's hand, unaware they are doing so, they cross the street and walk up the entrance way to the hotel. It is a medium-size establishment and the wooden steps are uneven. Lia nearly trips; Sam catches her in time; she is momentarily annoyed. Soon they walk inside.

They both scan the foyer for any sign of Raine—the area is

spacious, larger than they would have expected given the overall size of the hotel. They peer in opposite directions—Lia looks toward the piano in the corner, in front of the bookshelves, and Sam studies the reception desk and the person behind it. Lia sees a picture of a woman, a sketch, on a door and tells Sam it must be the ladies' room. He encourages her to go inside. She hesitates.

He understands Lia's reluctance; she may discover that Raine is not there, and, if so, they'll have no idea what to do next. Though Sam is sensitive to Lia's feeling at the moment, he is silent, impatient; he wants an end to this dismaying situation. They have changed their original plan and Lia has agreed to do so. Raine is familiar to him and Ned is not. He needs to distance himself as much as possible from Ned and Raine. As the only offspring of Jack and Naomi, he expects nothing less than full autonomy.

23

Raine was in the restroom. She is no longer there. Twenty minutes earlier, the hotel clerk grasped her arm, then the wrist of the woman Raine had been conversing with, and escorted them into the adjoining room.

While washing their hands, Raine and the woman, who was from London, had been discussing what they did and did not like about Antibes. The woman explained that she and her partner had been out late and had just got in—he had gone up to the room. She added that she was forty-four and divorced and wasn't certain this latest man was the right one—always difficult to know for certain, she said, eyeing Raine. Just as Raine was about to answer, the hotel clerk came in, her expression alert, and before they realized what was happening, they were escorted into the next room. They were informed that there was a situation at the hotel that potentially could put them in danger—a man with a gun, obviously unstable, was in the building. The clerk conveyed this information in a slow, precise English.

Raine reached to take her cell from her skirt pocket but remembered she had left it at the hotel. She explained to the clerk that her husband would be worried about her; he was at the park at the end of the road with two of their friends and she needed to contact him—could she use her phone? She was assured that this matter would be resolved quickly—the police had been called—and soon she would be free. At this moment there was no reception at the hotel as there was a problem with the cell tower. To allay Raine's concern, the clerk told her that if the situation continued longer than expected, she would help her contact her husband.

Before she left Raine and the other woman, the hotel clerk suggested they make themselves comfortable, but she spoke in such a disingenuous way that Raine sensed something was not right. The woman she met in the restroom did not seem to notice and only nodded, obviously thinking it was necessary to follow the directions of the clerk. For a brief moment, Raine considered running out of the room before the clerk closed the door. But she stopped herself from doing so in case there truly was a man with a gun.

* * *

Lia, standing outside the door of the restroom, rests her ear against the swirly sketch of a woman; she listens but does not hear a sound.

In the adjoining room Raine notices only one lamp on the

floor in the far corner and two plastic chairs in the center. The concrete walls are painted a muddy beige color and the tiles on the floor are terracotta. The hotel clerk has locked them inside.

Raine and the woman choose to sit on the floor rather than in the chairs. They are alone and feel stunned, but not frightened. Raine explains to the other woman that her husband and friends are resting on the bench in the park not far away and that she did not want to disturb them and did not tell them she was going to the nearby hotel. She had remembered the hotel—they had passed it earlier.

* * *

Outside the restroom, Lia takes a deep breath, grasps the doorknob, turns it back and forth multiple times. It is locked. Sam, standing not far from her, notices that Lia cannot open the door. He strides over to the clerk behind the desk, a man with dark hair and a narrow face. Sam describes Raine to the hotel clerk and asks if he has seen her recently, says the restroom is locked and he believes she may have gone inside and perhaps is locked in there. The hotel clerk tells Sam he just arrived and has not seen someone who resembles Raine or anyone else for that matter. The hotel clerk that he relieved has already left, and he could ask her in the morning if anyone she has seen fits the description of the person he is looking for. Also, she would not have locked the door of the ladies' room unless there was a plumbing problem.

Sam, trying to control his anger, says that it is morning.

"Yes, sir, but I mean at a more reasonable hour in the morning." Sam thinks the clerk may be English; he does not detect a trace of a French inflection in his words.

Lia comes over to him, asks if he has found out anything about Raine. "Has anyone seen her?" She looks exhausted, he thinks, and he shrugs. Studying her husband, Lia understands that Sam does not believe what he has been told.

"What should we do next, Sam? If the restroom has been locked, then Raine was not able to go in. Where could she have gone?" Her voice is now high-pitched.

"Maybe she has returned to Ned," Sam says affirmatively. He begins to believe this is true, it must be true. He tries to convince himself. He glances over at Lia, who looks pale, exhausted from worry and doubts. She is concerned about both Raine and Ned, and she is doubting herself for having changed their plans so easily. He guesses she is promising herself she will not do so again. He feels suddenly tender toward Lia. He wants to take her back to the hotel and bring her to bed so she can sleep; hopefully they will realize it was a dream after all, that they are in Burgundy and not on the disquieting French Riviera.

Standing in the foyer, before the front exit of the hotel, they are not certain whether to leave or to stay. Could Raine possibly turn up? Are they leaving too soon? Sam rests his hand on Lia's shoulder and draws her close. He feels her heart beating; it is how he imagines the movements of a firefly, disarming and without restraint.

24

Raine tells herself she is trapped in a room with a woman whose name she does not know; she takes a deep breath. Her anxiety evolves in slow motion until she is in a state of near panic. Is there really a man in the hotel with a gun? Or was the clerk using it as an invented excuse to lure them inside this room?

The woman sitting across from her has fallen asleep, her head rests on the seat of a plastic chair. She sleeps with an anguished expression. Raine regrets that she has not thought to ask her name; she wants to call out to her, to rouse her from her sleep. For a moment she wonders if this woman is involved—why did she so easily agree to wait in the room with her? She trusted this woman.

Raine crawls over to the woman, her bare knees scraping against the tiled floor. For a moment she forgets where she is, that she is married, that she is in Antibes with two others in addition to her husband; all she thinks of is this woman—that

they are locked in this room. Not only is her focus not on Ned, it no longer occurs to her that alerting him to where she is, to what has happened, should be her first concern.

She wonders if she is losing her sense of reality. She touches the woman on the arm as though reaching out to smother a flame, then draws away just as quickly. She needs her to awaken, to reaffirm what has happened, to ask directly if she is complicit. If she is not, they must escape.

Raine shakes the woman's arm, hoping she will awaken soon. She tries again and again, and after a while the woman opens her eyes, her expression startled; she squints at Raine. "We met in the restroom," Raine says in a hoarse whisper, "we were escorted into this room and were told there was a man with a gun in the hotel. I do not know if it is true, I do not know why they are trying to detain us. All I know is I want to get out, I want to leave." Raine no longer speaks in a whisper, her voice is more intense now; there is a tone of desperation in it.

The other woman clears her throat and says in a clear and sane voice, "Sorry, I was half-asleep. I remember you. There must be some explanation. We shouldn't jump to conclusions." She eyes Raine. "Is there something you are not telling me?"

"You don't find our situation strange?" Raine asks. "Why did we go along with the hotel clerk? We were like zombies. We did not question her."

"You are distraught," the woman responds, almost in an accusing voice. "Don't be concerned, my boyfriend will be suspicious when I don't return; he'll go to the front desk and demand

answers. Soon you will be with your husband and friends." She adds, "I am certain there must have been a man with a gun, they would not have lied about that. It doesn't make sense."

"Nothing makes sense," Raine says, crawling back to where she was sitting. The woman stands and presses down her clothing. Raine feels woozy, thinks fleetingly of Ned, then of her mother, but neither seem quite real to her. Her panic lessening some, she starts to hum.

"Please do not do that—it annoys me. And you are off key." With a nervous smile, the woman says, "My name is Rebecca, I hope I wasn't rude, but I think you are right; this is an odd situation. I went along, trusted what she said, but maybe I should not have done so, maybe we should not have done so—we should have asked more questions. You are correct—what is your name? I do not like being locked in a room with someone without knowing her name."

"Raine—it is Raine, with an *e* at the end." Raine smiles but she is very worried, more so than she's ever been, more worried than when Lee broke up with her, more worried than when she broke her leg when she was twelve, thinking she might never walk again. But in each instance she knew that she was overwrought, that there was a solution to her dilemma right around the corner—it might take time, but it was there. Now she had no idea what would happen, why they were there—had they been chosen, or was it simply an innocent mistake and the hotel clerk had indeed been looking out for their well-being? But so much time has elapsed, it seems—she isn't certain.

Raine stands up and starts to pace. Stopping suddenly, she turns to Rebecca and asks, "How do we remain sane? Are you certain your boyfriend will come to look for you? I imagine my husband and friends will come to the hotel; it is the closest open public place near the park and they will assume I was coming here."

"Yes, I am certain Jesse will come for me," Rebecca states unequivocally; she's sitting again on the floor, steadily rubbing one knee with her left hand. Raine senses a hesitancy in her words. It is in how she says Jesse's name, the way she stresses the first syllable but then draws back on the second. But Raine knows her senses are overly heightened. At one moment she believes she is dreaming and at the next she understands the harsh reality is that they are locked in a room, in a hotel, in another country. She feels off-balance; these states are at cross purposes.

"Do you think we should bang on the door?" Raine asks suddenly, "Maybe someone will come if we do." She feels an incredible sense of panic. Then she fleetingly recalls another experience that caused her the same degree of panic and she begins to pace, tears running down her face. But soon she forgets what it was; the memory has escaped her, she is unable to grasp onto it.

Rebecca studies Raine, her eyes steely and assessing. She is frustrated; Raine is emotional at a time when this will only work against them. It is imperative to be cool, analytical in this

situation, but Raine may be incapable of being so, she thinks, watching how Raine paces, her steps frenzied.

When Rebecca speaks, her words are curt and sharp. "We cannot act because we do not know what is true."

25

When Sam draws away from Lia, an expression of disappointment crosses her face; her lips press together, and he comprehends how deeply concerned she is. He knows Lia appreciates Raine and feels comfortable with Ned, but he also thinks there is something else on Lia's mind. He's been feeling this for a few months. The normally sedate Lia now possesses a hint of restlessness, very slight—you would not notice unless you know her as well as he does. It's something he never believed he would witness in her other than in their physical relationship. He gleans she is looking for something, for someone, and it is why she allowed Raine to convince them to change their plans. Maybe when he held her close just minutes ago, she thought she had found that something, and then was discouraged when she realized she hadn't.

"I don't think we should leave, Sam," she says in an imploring tone.

"Why?" he asks directly.

"Because I believe Raine is here."

"We should go to Ned soon. I do not think it is wise to leave him alone too long. He was pretty dazed," Sam says thoughtfully.

"We all know Raine is missing, and none of us has had the courage to say it."

"And by saying it now, do you feel that you do?"

"No, Sam—I think I am the least courageous of all. I said it because it cannot be denied any longer."

"Why do you think she is missing when you believe she is here, at the hotel? Then she isn't missing, she is here."

"Sam," Lia cries out, reaching for his hand. "Don't rationalize, you know she is missing too—don't deny it! Isn't it putting her in more danger by doing so? She could be at the hotel and missing within these walls."

"Are you certain she is here? She could have been abducted or wandered off on her own in the wrong direction, thinking the hotel was in another location. Maybe she did not notice the hotel as we did."

Lia crosses her arms firmly and he is reminded of her stubbornness—something he both loves and decries.

"You want to call the police?" Sam asks. He is the most uneasy he's been since they discovered Raine was missing. He thinks of Raine next to him on the train, leafing through the magazine, speaking about the break-ins at hotels in Antibes.

His words stall Lia; she does not like the idea of calling the police, which brings to mind an image of her mother, her hand tightly clutching the phone, threatening to call the police on her

younger sisters whenever they would not come home at a given time. And how her father would prevent her from doing so; with bitterness in his voice he'd tell his wife to wait a bit. Surprised by his tone, her mother would calm down. Sure enough her sisters would come woozily into the house an hour or so later. Calling the police is something Lia views as extreme, irrational.

Before she answers him, Lia goes over to the front desk. She describes Raine to the clerk. "Have you seen her?" Her voice is firm and accusatory.

The clerk says, "No, I told your friend, no—I just came on my shift."

"I do not believe you, I think you are purposely not telling me the truth," Lia says unequivocally. The clerk for a moment appears stunned. Sam guesses he finds Lia's tone nervy, and he must also be surprised how a small person could have so much force; he supposes that he may never have thought highly of Americans, perhaps believing they look down on him until he learned how to be even more condescending in return.

How little people understand other people's motives, desires, Sam thinks. Standing to the side now, he observes the change in the man's expression, sees he is caught off guard at first, but soon his expression is controlled again. This seemingly calculated change in the man's demeanor puts Sam on alert and he wonders if they should call the police, the authorities.

But Sam doesn't allow what he has noticed to linger; he wants to believe there is nothing nefarious going on, that Raine

is really not missing, that everything that has happened is innocent and by midday tomorrow he and Lia will be on their way to Burgundy. He needs to distance himself not only from this situation but from Raine and Ned as well.

"I think we should not wait too long before going to Ned; we can call the police if Raine hasn't shown up," Sam says, lowering his voice.

She feels him behind her, his breaths crossing her shoulder. She disagrees but knows there is nothing else they can do.

"Maybe I should stay here and you can go ahead and get Ned."

They turn away from the desk. Sam says, "I think we should stay together, Lia; we should not separate. Let's wait twenty minutes more, see if Raine shows up, and then if not, or if she does, we will go to Ned." He has never felt more certain, has never been more himself.

He takes Lia's hand and they walk into the sitting area and rest on the sofa. He thinks of their trip to Hawaii—it wasn't that long ago; that is where he noticed the change in her and he isn't certain how long it has been going on, how long it has been evolving. He doesn't want to have a marriage like his parents. He thinks of his grandmother; she had been his escape hatch, the person who had given him freedom to be more than simply the son of Naomi and Jack.

Lia lightly rests her head against Sam's shoulder; soon she is asleep. Her dreams are even more sensual than the ones she's

had before and there is a person in the distance—wondering who it is, she is frustrated by her inability to discern whether the figure is male or female.

Sam closes his eyes and dreams about Naomi and Jack walking down a dark street in the old part of Antibes, holding hands.

26

Rebecca watches Raine pace—her torso forward, her feet lag-ging behind. Rebecca sits on the floor, hugging her raised knees; she studies Raine's frightened expression—she must calm her down.

This situation is intolerable, she tells herself—why is she unable to get any reception on her cell phone? Why isn't Jesse tracking her down? She first must deal with what is before her. They are in a pickle and this American woman is frantic. The Wi-Fi has been disconnected or cell phone connections have been barred in this area. She does not know if she can stop Raine from pacing. Her preference is to approach her, to hold her by the shoulders and firmly tell her to calm down, to stop—it is irritating and prevents her from thinking her way through the situation. But she believes Raine may not react well, may try to fight her off. What other alternative does she have?

She tries to remember what Raine has told her about her-self; maybe if she mentions something that she said it will bring

her back to reality. For Raine is in a state of shock—she does not know where she is or maybe even who she is at this point. Rebecca recalls their conversation in the restroom. They had begun to talk because Raine had said that she liked her skirt—an unusual color, the same color of the dress her mother had purchased for her in San Francisco when she was six, the first time she had taken her shopping, she believes, after her father had passed away. Rebecca was surprised at Raine's nonchalance, how a look of dissociation had crossed her face. Rebecca decided at once to shift the conversation. She asked Raine what she thought of Antibes. Her words seemed to bring Raine back to reality. Then Rebecca told her that she was uncertain about her boyfriend, whether or not he was the right one for her. At that moment the clerk had come in and had escorted them to this room.

Raine is impulsive, Rebecca thinks—how do I get through to her? She needs to calm down.

"Your birth? Where were you born? The date?" she cries out to her, not knowing why she is asking such questions, not knowing whether she will be able to pierce through the miasma of confusion that Raine is experiencing.

Raine, pacing more furiously, says, "San Francisco," emitting a foghorn of sound over her shoulder. It takes a few moments for the name to make sense in Rebecca's mind.

"San Francisco," Rebecca cries out. "Tell me about the city."

Raine, in a frenzy, continues to pace back and forth across the room. She is like a cooped-up animal, Rebecca thinks, a

fragile, cooped-up animal. She doesn't believe Raine has heard her or has processed her question. Raine breathes heavily now.

"Rain, it rained, poured, the day I was born," Raine cries out, her words slightly clearer now, but she continues to pace.

"And your husband, did you meet him in San Francisco?" Rebecca asks with cutting determination, hoping to jar Raine, bring her back to reality, make her aware that her husband is not there and may be very concerned about her, that the two of them are stuck together in this room either for their protection or for some unknown reason.

Raine does not answer. Rebecca stands up abruptly, tightly crosses her arms, then she goes to the door and bangs on it with both fists. She doesn't yell; she doesn't know what impact it could have on Raine—it may frighten her more, and a more frightened Raine will only make the situation worse.

No one responds to Rebecca's banging and she wonders if they are alone on the first floor or if the room has been soundproofed. It fleetingly crosses her mind that they may be hostages—but by whom and for what purpose? Out of the corner of her eye, she studies Raine, wondering if she is a significant person in one way or another. She waits a few minutes and then, weary and discouraged, she turns away from the door. She thinks of Jesse, wonders how well she knows him, why he isn't searching for her now.

She is surprised to see that Raine has stopped pacing and is now sitting on the floor in a corner of the room, her head down, but when she lifts it there are tears streaming down her

cheeks. Rebecca feels a sense of mild hope; Raine possibly will be easier to talk with now, maybe she is returning to the present.

She goes over and sits next to her. "It will be okay, Raine, don't worry—I think there is a mistake; I am hoping we'll be out of here soon."

"I don't know," Raine says; she is sobbing now, her shoulders shaking.

"I am thinking of a person," she says in a voice slurred from crying.

"Your husband," Rebecca asks sharply. "Do you mean your husband?" Her tone now is more solicitous, trying in any way that she can to coax Raine to a semblance of normalcy.

"No, it is about another person, something odd, something familiar . . ." Her sobbing increases.

"It may be your imagination," Rebecca responds in an even tone, realizing it is best to be herself; she is getting nowhere by being either curt or cajoling.

Turning away from Raine, Rebecca stands up and begins to pace. After a few moments, she hears Raine's voice, soft, husky, persistent; her words at first are nonsensical, yet soon clear though scattered, and, at last, they flow.

27

Sam, awakening, feels the weight of Lia's head nuzzling his shoulder; her breaths steady, her forehead moist. Gingerly, so as not to awaken her, he shifts his body to the side, then leans back for a short while; the brocade material is discomforting, the sofa is hard. He checks his watch; they've been sleeping for nearly thirty minutes. Lia stirs, brushes her lips against his throat, mumbles something—a name? He isn't certain. It doesn't matter; she is only dreaming. Yet he experiences a strong pull of doubt; these past few months his unease, though not visible, has been deep.

He pictures her in Maui, strolling down a street with many shops, wearing a strapless dress, a vivid green color, an expectant expression crossing her face—sensual; it was unlike her. She seemed different; it was a side of Lia he had not before witnessed.

On the third night she awakened in the early morning hours, unexpectedly stood up, hastily unbuttoned her nightgown, let it slide to the floor. A curling smile crossed her lips; it was nearly

out of character. He'd been half-asleep and soon she was on top of him, caressing him with her face, then her lips pressing hard against his chest, his abdomen. Was this the same Lia, or had she been transformed into another person, more demanding, more physical? At first he relished the change in her, unthinkingly went along with it, loving her more than he'd thought possible. But on the return flight to Boston, he saw that she had become tense, more so than before, and he wondered what was behind it. Had she been making love to him or to some imagined person—or was the person not imagined at all, but real?

Once they were settled in their apartment again, he lightly questioned her to see if her day-to-day schedule had changed—it would have aroused his suspicions if it had—but easily she indicated that everything was the same. Astutely he'd listen whenever she spoke of her work at the school. All he could make out was that she was very hard on herself—her class was unruly this year and, as usual, whenever something went wrong in any aspect of her life, she would more or less blame herself.

When he first met her he hadn't realized she was highly self-critical; instead he thought she was impassive, not easily ruffled, but the more he knew her, the more he realized she was too strict with herself. By the time they married, he thought for the most part she had cast off that judgmental view of herself. But it still is there, less obvious at times and very apparent at others.

He considers asking her whether or not she is happy in their marriage. Is she interested in someone else? But this idea

causes him to feel constricted. Then he forces himself to imagine her response; her expression set, her eyes earnestly looking into his, "Why would you ever think that, Sam?" For if she was interested in another person, she would be angry with herself for letting her emotions focus on another person—she'd refute her feelings. And he would answer her by saying, "We are human, Lia." And she'd look at him directly and say, "Yes, we are, but if we understand who we are, then we know who we love, and how we love."

Because of her sound nature, he knows it will be useless to bring it up to Lia. He has other worries—if he is unable to find a new job, he'll need to go to his father and ask to work with him until he finds another position, or forever. Even while away, he's been checking; the job market has been tightening this summer. More and more he knows he needs to leave his position soon. But no matter how Sam presents his situation to his father, Jack, in that stubborn way of his, will believe it will be forever. The thought of this causes Sam more anxiety than he's experienced before, even more than when he was searching for his first job.

He's never had a good read on his father. When he was a child, he admired him, appreciated that he'd bring him to his cabin in New Hampshire or to Red Sox games where they'd devour hot dogs and munch on popcorn. But inevitably a friend of Jack's would come by and join them, who would monopolize their time together. Or maybe it was Jack who needed to be diverted from his son—not intentionally, but because of who he was.

Sam has not expressed his concerns about his professional future to Lia. On a snowy Sunday afternoon last January when they planned this trip to Europe, they both were in a different place. Lia had only vaguely mentioned her disruptive class to him, must not have been too worried about it. And at the time he had no idea that the stock market would fall so dramatically that spring—a new job would be more difficult to get.

Once the beginning of June came round, neither of them had had any desire to travel to Europe, but they had stuck to their plans and hadn't canceled. He finds it ironic that he was the one who insisted they go on this trip, but he had done so because he knew she needed a change, needed something more. Now she's met Raine and has become very attached to her.

To him Raine is elusive. Yes, she does remind him of someone he met once, but he is almost certain she isn't the same person. Although she physically resembles her to a degree, her personality is quite different—this person was softer, cooler, more indirect, not as rushed and restive as Raine.

He doesn't want to mention to Lia that Raine knew about the break-ins at the hotels in the old section of Antibes before they arrived. Why would Raine have taken a chance and wandered away by herself, to not ask one of them to accompany her? If she knew, Lia would be disappointed in Raine.

Again he thinks of the woman he encountered in Florida a year before he met Lia; he still finds it puzzling. He did not consider her attractive though her personality was kind in a loose

way. They were staying in the same hotel, and would lie out on the beach, on separate blankets, refusing to acknowledge each other's presence—it was strange, he thinks. Whenever it crosses his mind, he likes to divert himself. It wasn't a pleasant experience, though at the time, because of his age, he was not bothered by it; he found it enticing. But some months later he realized how odd it had been.

They'd be out on the beach and she'd unclasp the top part of her bathing suit to tan her back and from twenty or so feet away he'd watch her steadily for a long while. She'd turn her head to the side and avoid his gaze. And when leaving the beach, their eyes would meet and she'd immediately look away, pretend she had not noticed him.

In a normal situation she would have said hello, they'd have talked, and soon they would have been lying next to each other on towels or beach chairs; they would have conversed. Maybe they would have gone out for a few nights as friends, maybe they would simply have had a vacation romance, and not have seen each other again. But normally they would have communicated in one way or another.

Though there was that one night when they were the only ones out on the patio and the bar was open. It was pitch dark and cloudy—the stars were invisible. The sound of breaking waves was nearly inaudible. At first they maintained their distance, but they were drinking and he doesn't remember much after that. But he is certain the woman was not Raine—she couldn't have been—it would be too much of a coincidence.

Lia stirs again, opens her eyes dreamily but soon shuts them. He kisses the top of her head, wondering what her fascination is with Raine, hoping she is not in love with someone else. All he knows is he can't lose her—he loves her, yes, without a doubt, but also he has no one else.

As the only child of Naomi and Jack, he is accustomed to positioning himself as the calm, centered person in nearly every situation; it was as if he'd been the parent and they were the excited, self-occupied children he had had to keep in rein, always negotiating between the two of them. And whenever he would question them, their motives, his father would throw up his hands and say, "We live in a *crazy* world, Sam."

He closes his eyes and thinks again of Lia, now breathing deeply in his arms—he recalls the four of them at the breakfast table in Edinburgh, choosing their favorite artists.

He imagines Lia's voice, light, yearning, calling out, "Colette." Or was it Gauguin? Unusual for him not to remember. Or is he thinking of Colette because Lia is reading one of her novels? The name of the artist or writer is inconsequential, he thinks—the unabashed desire in her voice was what stung him.

He takes a deep breath, and, in doing so, he realizes he may have awakened her. Lia's eyes are still shut, her lips curl into a smile; her voice groggy with sleep, "Helter-skelter," she mumbles.

28

Raine sits on the floor, her ankles crossed, her chin tucked in the hollow between her raised knees; she slowly opens her eyes and looks over at Rebecca, who, with legs outstretched, palms down, sits across from her. Raine's coloring is wan, her face appears more narrow than before, the dark circles beneath her eyes have a purplish tinge. She appears deeply wounded.

Although moments before her words were quietly flowing, she suddenly ceased speaking. Having been recounting to Rebecca her vague memories of San Francisco—soft rugs, wooden sculptures on a shelf in the office that had been her father's, a large mahogany desk, a kitchen window staring down a sharp incline—she is at a loss. In San Francisco she was still in the womb, not able to extricate herself, not knowing where she was, her realization of a larger environment was beyond her grasp.

"Our life in San Francisco was more than I could understand—the same as now," Raine speaks again. "We do not know

why we are here or when we will be released—there must be an explanation—innocent or criminal?"

"Is there a difference?" Rebecca asks, her voice edgy.

"Of course," Raine responds. Startled, she flushes, adding a hint of color to her complexion.

"Isn't it criminal to be innocent?" Rebecca asks, her tone, caustic. "Your innocence may hurt someone or many—though inadvertently—and in the long run you are not regarded as a criminal but the effect on the individual or society may be just as harmful. What I mean is that a friend or partner of yours may be stealing money from the company in which he works and due to your deep knowledge of this person's mood, you may have picked up on something unusual in his behavior, but you disregard it because your belief system is more of an innocent one."

Her words smart Raine, though the sting is short-lived. She decides to ignore Rebecca's words; she does not believe they have any relevance to their present situation. Sighing, she again speaks; her tone is cautious. She says that her family didn't move to the east coast until her sixth summer, a little over two years after her father had passed.

Slightly intrigued, Rebecca acknowledges to herself that she has nothing more productive to do now but listen. In a mellow voice, she asks Raine what she remembers about her father. If she can keep Raine talking, it will help pass the time. For Rebecca has decided if they have not been released in a few hours she will start screaming at the top of her lungs through the crack at

the bottom of the door; she will scream in such a high-pitched voice that someone for the sake of their sanity will come and let them out. She intends to do so at six in the morning. Calmly she checks her watch—two more hours to go. As a personnel manager, Rebecca is pleased that she has always been able to compartmentalize her life, which has led to both her successes and her failures, the former in her professional life and the latter in her personal one. Raine stops speaking. Rebecca repeats her question; she knows how important it is to keep Raine talking, diverted and relatively subdued.

"I have no memories of him," Raine says deliberately, "I imagine him as smaller than my mother, though I was told he was taller than her, but not by much. In the photos I have seen of him, it seems as if he is holding himself together. When I was a child and would look at the photos, I'd think of the Humpty Dumpty rhyme, and that he held himself in because he might be afraid of falling apart. I never envisioned him sitting on a wall. In many pictures of him, he is standing. And in the photos of my father standing next to my mother—Dania is her name—he seemed not to take up as much space as she did."

Rebecca notices a tenderness in how Raine says her mother's first name, and a wariness too. She says, "I realize your father passed when you were four years old and you were much too young to understand their relationship, but looking back on that time and how your mother has spoken of him since, do you think they had a strong relationship? Sorry if I sound intrusive. I will forever be looking for examples." She smiles wryly.

Raine, touched by Rebecca's honesty, says, "I do not remember anything about their being together when he was alive; I do not recall him—I only know him through photos. But I imagine most children think of their parents as separate. I do remember how sad my mother was a year or so following his death. I seemed to be the only one of the children who worried about her, I was the only one of the three of us who noticed her sadness. I would go and stay with her at night. I couldn't sleep because I was concerned about her. If you judge their marriage by her sadness following his death, I guess you could say that they must have had a good relationship, if grief is an indication of how deeply one loves." Raine shrugs and easily stands up, turning away from Rebecca.

"Have you ever danced, Raine? You have the perfect form for it, I think—strong and lithe." Rebecca smiles and says, "Come and sit next to me, Raine—I want to hear more about you."

Still looking away, Raine shrugs again, "I'm not very exciting. I hope we can get out of here." Looking over her shoulder at Rebecca, she says under her breath, "Don't worry, I am not going to lose my mind again—once is enough. It is how I am; I may appear a little crazy, but I'm always able to calm myself. Though I still feel in a bit of a daze."

"Tell me more, Raine."

Raine twirls around and says, "Okay, but you need to promise you'll tell me your story too. It's about all we can do right now." Gracefully she sits again on the floor, seeming to be relieved of some burden, and says, "I just remembered

something about my father's office—it wasn't a fancy one, just a desk, a telephone, and one shelf with books and the small sculptures he'd collected. There were also photographs on the wall; I don't remember who they were of and maybe I never knew those people, or maybe I was simply too young to recognize them at the time. But I liked to go alone into his office and sit beneath his desk—I began to do so about a year after he passed away. I'd imagine my father was alive and I was expecting him to come into the room. And if he did I would jump out and surprise him. The desk chair had legs with rubber rolling fixtures at the ends, and I'd imagine him sitting in it. In his photos he appears mostly sad and tense. There is one photo of me and him and he is smiling; he is sitting in his office chair with me on his lap. My mother said I was three at the time. But in most of the photos he appears sad. I think that was why he must have fallen in love with my mother—she was the exact opposite of him."

"When we moved to Cambridge a few years later, we lived with my aunt and uncle—we did so for three years as my mother needed to organize herself, establish herself, decide what she would do next. It wasn't that much time since my father had passed. To a degree, she was still in mourning but was much better than she'd been in San Francisco. I was more upbeat about our life then, and felt that I could be a child again."

"That is good to hear," says Rebecca, nodding. Raine wonders if she is only half listening, if she is thinking again about how they will extricate themselves from their present situation.

Raine hopes she is—she herself, uncharacteristically, has drawn a blank on what to do next.

And so she continues, almost reluctantly, "One day something unusual happened. I was home from school—I was sick with the flu. My aunt must have believed I was sleeping. She was speaking on the phone to my uncle; he'd call her from work a few times each day—my mother was out shopping at the time. Dania usually bought the groceries—that was how she paid them for their generosity. And I believe my aunt and uncle were discussing my father's death. My aunt did not say his name, but I was certain they were referring to him. It upset me very much."

"What did they say?" Rebecca asks. Her voice is insistent, her curiosity aroused, and for a moment she forgets where they are.

"As I mentioned, they were speaking of his passing—which I believe had happened five years before; I must have been nine by this time. My mother had recently purchased a house of her own, and we were to move soon. She had saved up enough money by then, and of course she had money that my father left her."

Rebecca looks at Raine directly as if this information in one way or another will help them out of their present situation.

"They spoke of responsibility—as if someone was directly responsible for his death, and I was alarmed. I'd never heard that possibility mentioned before."

"What was the cause of his death?" Rebecca asks.

"When I was young, I was told that he'd had something

wrong with his stomach. When I was older, I asked my mother again and she said that he had had an infection and once it was discovered it was too late to prevent it from spreading, though they did try. But her explanation never really made any sense to me. My mother's expression was different, one I'd not seen before—she appeared stunned, frozen. She turned away from me—I thought she did not want me to see the tears in her eyes. My impression was that she wasn't certain herself, but that was what she'd been told. Though she was trained as a nurse—it was baffling, but I didn't want to think more about it."

"Did you not bring it up with her once you were an adult?"

"I couldn't. I had first asked about it after I'd heard the conversation between my aunt and uncle. I'd nearly forgotten about that first conversation when I asked her again; I must have been seventeen or eighteen then. It wasn't something I'd thought much about at that age. But later it kept coming to mind and soon I'd forget about it; it wasn't something I wanted to ponder, but whenever it would come to mind, I'd feel sick and lost. I've never told my husband about the conversation I'd overheard. It is because I'm not certain whether or not I imagined it. It was so long ago, but it is so sharp and painful whenever I recall it, especially now when we are stuck in this room. It is the same feeling: you do not know if you'll ever be aware of the truth—the truth about his death or the truth about why we are here."

"Well, I am confident we will get to the truth of why we are here—I will insist on it," Rebecca says with a harsh confidence.

Raine looks at her warily, and feels she is more uncertain

than she appears. "I've concluded it isn't good to mull over what I'm unsure of—I realized this once I met Lee."

"Who is Lee?"

"The man I was engaged to—he broke it off. He thought I didn't care enough for his child from his first marriage and he was probably right. I was too young to deal with a four-year-old boy. I've never been very good with children. Ned, my husband, wants us to have at least one—though I am not convinced. Lee was much older than I was, and my mother told me I was looking for a father figure. I didn't necessarily agree but in retrospect she may have been right. I met Ned very soon after the breakup."

Rebecca checks her watch again and says, "In an hour I am hoping we'll be able to get out of here."

"Why?"

"I have a plan."

"Will you tell me what it is? I need to have hope," Raine says insistently, clenching her hands together.

"I understand—we all need hope. I'll let you know when the time is right—if I tell you now, you may not think it a very good plan, and it is all I have at this time. I do not want to be discouraged."

Raine nods, then stands and is about to begin pacing again.

"Raine," Rebecca calls out a little nervously. "I think it is best if you don't pace now. I think it is important that we stay calm and quiet. I do not want us to draw attention—I mean I do not want anyone to hear us now. If this is innocent and there

was a man with a gun, then we will be released as soon as the authorities think it is wise. And our being loud or being quiet will have no effect on what happens to us. But if this is more nefarious, then I think it is best to stay quiet—I mean to stay quiet for now."

Raine turns around and sits again across from Rebecca. She raises her knees, her feet together, and wraps her arms round her legs. She feels angry with Rebecca—given the circumstances, she is unnecessarily evasive. Of course Rebecca should say what she intends to do. Raine believes her mind is clearing up some, she feels less dazed.

Rebecca looks at her and smiles; she believes she is reading my thoughts, Raine surmises.

"You have more to say, don't you, Raine?" Quickly she reviews in her mind what Raine has told her, searches for a question to ask. There is something more about Raine that she is not able to put her finger on. Because of her work, she is considered a good judge of people. She puts aside what Raine has said about her past and thinks of the present. "Why did you come alone to the hotel at one in the morning without telling your husband or your friends? You are in a foreign country; though you may have visited Antibes before I cannot imagine you are well enough acquainted with the city to know where the safe areas are, and where it may not be so safe."

Raine looks sharply at Rebecca. Then her demeanor softens as quickly as a balloon deflates once the air has been let out. "Yes, Rebecca, you are right. There is a reason I wandered away.

I could not stay anymore. I did not want to be with them. It's not that I wanted to get away from my husband; it is the other couple. I wanted to get away from them. I think I may have met the woman's husband before but I am not certain. It was soon after my engagement was broken. I was in Florida and I had seen Ned, but we had not talked very much yet and at that point had not even imagined we'd become involved, or marry. There was a man at the hotel, and he seemed edgy, nervous. This was a little over twelve years ago, and you know how people resemble one another so I am not sure it was him. And I needed to escape the uncertainty. I was too embarrassed to ask. I've been with people who have approached others, asking if they were someone else, and it never is the case, usually people are mistaken. So I am not sure. It was the uncertainty that caused me to leave the group—I was becoming more and more restive, anxious from the possibility that it may have been him."

"What happened between you and the man? Something must have happened or you wouldn't have wanted to leave. You were vulnerable at the time. What is it, Raine?"

Raine's heart begins to race. "I felt he was watching me, that he wanted to talk with me, but I do not think he liked me in that way—what I mean is that he wasn't flirtatious. It was very odd. But it would be too much of a coincidence—so I think it wasn't him. But at the least he is a reminder of what happened—I mean what happened before I began seeing Ned."

"Did you sleep with him?" Rebecca asks directly. "Is that why you needed to get away?"

"No—I do not believe I did. I mean, it was twelve years ago—I do not know. But I do wonder—this is the problem. One night we were out on the deck at the back of the hotel; we were the only ones there. It was the middle of the week and there was a bar and we were both drinking. And I am not certain he is the same person. It was twelve years ago." Raine's voice trails off and she begins to sob.

Rebecca comes over to her, hugs her; drawing away from Raine, still holding on to her arms, she says, "It doesn't matter; whatever happened, if anything, this other man most likely wasn't your current friend. Your memory is playing tricks on you." As she embraces Raine again, she checks her watch—it is five minutes to 6 a.m.

29

Lia's dream is whirling, exhausting, a merry-go-round of color—she finds it suffocating, exhilarating. She gasps for breath, longs to extricate herself from what surrounds her; she is filled with a desire that is sharp, haunting. Frustrated, needing to escape her feelings, she awakens to find herself resting on a sofa with Sam, his arms round her; gradually she recalls where she is and why she is there. Raising her head, she peers into his eyes; her voice husky from sleep, she asks, "Have you found her?"

He doesn't respond; his eyes are now alert—she sees how his ears are cocked as if detecting sounds. "Quiet," he says. "I think I hear screams, very faint ones." He loosens his arms from Lia, then stands and steps furtively toward the reception desk. Lia waits; she has no idea what Sam may be hearing. She is not aware of any noise at all; it is very quiet in the lobby, near silence.

Sam's hearing is unusually sensitive, better than any per-

son she knows. He's told her it is because of those days when his father would take him to his cabin in northern New Hampshire to listen to nature. It sharpened Sam's auditory sense; it is where he learned how to listen, how to differentiate between sounds, pick up on what most would not catch.

Lia doesn't move from the couch. She remains still. She doesn't want to prevent Sam from hearing more. His steps are both hurried and cautious; he is like a snake, confident in his slithering approach.

From the sofa she watches the clerk behind the front desk, innocuous-looking now; he's filing papers away, checking his computer from time to time, but does not seem worried or nervous. She senses that nothing seems out of the ordinary to him. He turns his head away as Sam passes the desk. She remembers thinking of the clerk as innocent at first. Yes, he is an innocent man, she believes, studying him. Why did she and Sam later view him with suspicion? She answers her own question: it is because of what they did not know; their suspicions were misdirected, at least hers had been.

She loses sight of Sam and becomes anxious, her heart pounds erratically. Suddenly she is alone; Sam protects, it is his inclination, his nature. She's always been safe with him. But now, in another country, in the early morning hours, Lia, for the first time since they've been a couple, believes she is no longer safe. Angry with Sam for leaving her alone, her face reddens. Her anger is harsh and unyielding. Why did she not follow him? Would he have prevented her from doing so? He said they should

remain together, that it would not be wise to separate. But he's gone forward without a thought, determined to discover where the faint screams are coming from; his focus is complete.

He is as compelled as she is to discover what has happened to Raine. But she knows there is more to it; always, there is more.

Sam is in the hotel; tenaciously, she holds on to this thought. He will never leave without her. But then again, Raine has disappeared.

30

The text message Ned has received is not from Lia or Sam; it is from a colleague who believes Ned has returned from his trip. He's asking to meet with Ned the next day at their favorite restaurant in the North End. He wants to discuss an article they've been working on together concerning protests in Turkey. Becoming concerned again, Ned types that he is still in Europe and will contact him in a few weeks.

Rising from the bench, he begins to pace. No longer self-absorbed, he's thinking only of Raine. Why did she leave without saying a word? His puzzlement overlaps his worry, his anger tempers his emotions, somewhat clearing his mind.

It's not like Raine to disappear. At times she can be distant, detached, he acknowledges. At such moments he'll be filled with frustration; it's as if she's behind an opaque veil he longs to brush aside. She'll sit before him, her hands crossed, her gaze not meeting his; she'll look away, her pale green eyes still. In a detached manner, she'll usually begin to talk about her father,

how she has no memories of him and cannot connect him to other parts of her life.

Ned has concluded that Raine's childhood consists of three different frames: a year or so after her father's passing, the move from California to Massachusetts, and then her life in Cambridge. And these portraits of her childhood are separate from her present life.

"My recollections of living in San Francisco are few, but rich," Raine will say to him whenever they talk about her life in California and she is fully present. At these moments she'll meet his gaze and smile, appearing more effervescent. "But I was so young, it may be that my memories are prompted more from photographs than from anything else. It was impossible for my mother to fully become a Californian and my father, I imagine, could never have been anything else; our family life may have been removed from the larger world. My father's parents retired and moved to Maui—I don't remember them. He was an only child and so I did not have aunts or uncles or cousins from that side of the family." And then Raine will swiftly change the subject, talk about something in their current life.

But most revealing have been Ned's in-depth conversations with Dania, which would occur only when she was in one of her introspective moods, had had too much wine at dinner and Raine had gone off to meet an old friend—a perfect storm, so to speak. Usually it would be after dinner, and Raine would have received a call from a friend, asking her to drop by.

Dania and Ned would sit alone until the room was nearly

dark. Lounging in a wide and soft armchair, a wine glass cupped in her round hands, she'd neglect to switch on the lights. Once he'd offered to do so but as he rose from his seat, she put up one hand, saying that at this time of the evening, she found the light intrusive. She'd unbutton the top button of her shirt because it would be summer and Dania was not partial to hot August nights. She'd begin by saying that Raine was nearly six and a half years old when they left San Francisco, her father had passed a good two years before. Dania would add that there was something different about Raine as far back as she could recall, that her friends considered her daughter odd. There were days, even weeks when Raine would be inconsolable, refuse to smile. And whenever she was in this mood she'd crawl beneath her seat at the dining table, and not come out until Dania went over and picked her up. Holding her in her arms, she'd tell Raine to smile at the guests.

"I was concerned Raine would be uncomfortable in social settings when she grew up. Life is challenging for those who are shy in this way." And Ned would wonder if Dania was attempting to warn him in some way about Raine, or if there was something she felt guilty about in regard to her middle child.

Then, as if to divert Ned, Dania would hastily turn the conversation from what she'd just told him to how Raine would often steal into her father's study. "Edward," she'd say, "was a refined-looking man with a soft, purposeful gait, interested in fascinating pieces of sculpture from all over Europe. Raine would wander into her father's study and stare at the pieces. It seemed

strange for a child that young to be compelled by carved wooden sculptures; she would stare at them with the intensity of an adult. I've asked her about it, but she's told me she doesn't recall knowing her father. I suppose it is difficult for most to remember anything before the age of five.

"One day Edward walked into his office just as Raine was picking up one of the pieces—she had pushed the desk chair over to the shelf and was standing on her tiptoes reaching for the sculpture. She must have been three years old at the time. She easily could have fallen."

Dania said that she had passed by at that moment and had seen the most unusual expression on her husband's face. Then he waited—a little too long, she thought—before stopping Raine, and it had struck her that maybe she didn't really know her husband. But soon he went over to Raine; he lifted her up then put her down carefully. He did not reprimand her, just quietly told her not to do that again.

Dania said that Raine was an inquisitive child—maybe she needed to know more about her father. She would sit beneath his desk and watch him, her eyes following his every movement.

One day Raine had followed him about the house and when he noticed her doing so; he didn't wave her off—it wasn't in his nature to discourage. Then suddenly he turned round and lifted her up, carrying her about their home in his arms, and Raine was filled with glee and awe. He was surprised himself, Dania said, not believing he had done this. He had never felt particularly at ease with children, even his own. But he loved

his children, no doubt. He just didn't feel adept with them. It was obvious.

"Exuberant Dania, he'd call me, and he'd flash a smile, a very genuine one. Edward, you give me far too much credit, I'd say. Even as a child Raine would ask, why do you say Edward— and then I'd laugh. When her father picked her up that day, Raine called him Edward. He didn't respond at first; he looked concerned. But she said it again, and this time he laughed. He laughed naturally, effortlessly, and Raine looked surprised, maybe afraid, but soon she grinned as if she were very pleased with herself.

"I will never forget that moment," Dania would say, her expression blank. "It was the best of Edward."

Once finished with this story, Dania would remain silent for ten or so minutes, then she would sigh, take a long sip from her glass of wine, and say that Edward, Raine's father, was more reclusive than she was. She'd wonder if Raine would be more like him. "Edward and I were opposites." Next she'd lean forward and whisper to Ned that she had not wanted that sort of life for Raine—she wanted her to be social. But Raine was only partly so and she had had to learn to accept it. As Dania said this she'd have a distant look in her eyes that would disturb Ned. He'd tell himself that she had had too much to drink and she worried too much about Raine.

It is odd what comes to mind at times like these, Ned now thinks, bringing himself to the present. He last heard Raine's throaty laughter in their Paris hotel room a few nights before.

And this recollection causes him to lose his objectivity. His concern for Raine is palpable—he doesn't know what to do next. Calling the police will only confirm the situation is hopeless, that Raine is lost.

His cell signals another message has come in. His hands moist from anxiety, he takes his phone from his back pocket. There is only one word: *FOUND*. Jumping up, he heads in the direction of the hotel; walking swiftly, he speaks into the phone, "On my way."

Lia, Sam, Raine, Ned

Two Years Later

31

The moment Lia spotted Raine in the breakfast room of the Edinburgh hotel, she gleaned there was more to this woman; she was someone whom she needed to comprehend. She had been mildly disturbed by her presence—she had hit a nerve in her in some way—though Lia's curiosity had been stronger than her unease about Raine.

Initially Raine had been a reminder to her of those years she'd escaped the confusion of her family to wait out the time until she'd be able to move past her life in Richmond. Her sole desire was to leave all the disorganization she associated with her parents and siblings in the rearview mirror, to no longer try and imagine possibilities that would never come to fruition because of who they were.

She turned to four friends she'd been close to since elementary school—all female, all her age. But in recent years another had joined the group. The newest member had moved to Richmond when they were in eighth grade. Her name was Shirley,

her parents were divorced, and she and her mother had moved from New York City. Shirley had said she had lived in Richmond when she was very young, but had no memories of the city.

Upon seeing Raine that June morning in Edinburgh, Lia had recognized a quality in her presence that had reminded her of Shirley. Although Shirley was blonde, with a ruddy complexion and broad cheekbones, and Raine's coloring was more olive, her eyes a pale green, her face narrow, they both wore a similar expression—they were both very much in the present, but at the same time a detached look would come into their eyes when least expected.

In her first glimpse of Raine conversing intently with Ned, Lia read preoccupation in her manner despite how involved she appeared in her interaction with him. Though she was leaning toward Ned, the foot of her crossed leg was twisted in the opposite direction; when he didn't notice, she'd look away, her eyes seeming lost. She wasn't all there; she was diverted, diverted by whatever she was hiding about herself from him, maybe even from herself, Lia had understood. She was not who she seemed to be. And it had sent a chill up Lia's spine. Yet it had compelled her to want to know more about this woman.

Over the past two years, Lia has been struck by one memory or another of that time with Ned and Raine. It was, after all, a watershed in her and Sam's lives. They would not have landed as they had if it hadn't been for those last days of June with Ned and Raine. She wasn't certain whether or not it had been a smooth landing, but it had been one nonetheless.

At times she'll also think of Ron, how she had toyed with calling him when she returned home, needing to tell him about their adventure in Antibes. But she waited until the fall, the first day of school. She knocked on his office door—"The Music Room." But there had been no answer. Then she overheard in the teacher's room right before leaving work that day that a new music teacher would be starting at the school in a few weeks, that Ron had moved with his family to Nashville. When she got into her car, she grasped the steering wheel, her shoulders shaking, tears spilling down her cheeks. Had her intention been to have an affair with him? Is that what she had wanted all along? She harshly laughed at her innocence—or was it lack of insight?

* * *

From their time in Antibes, she'll recall certain emotions with such clarity it will seem as if she experienced them yesterday, especially her extreme anxiety at the thought of losing Raine, her desperation, her need to find her. Her anger at the unfathomable connection she perceived between Raine and Sam.

She'll recall how they had waited at the hotel until the early morning hours. She and Sam had fallen asleep on the sofa in the lobby. When she slowly awakened she saw that Sam had not been sleeping as deeply as she had. They had not thought to text Ned to say they had reached the hotel. They were annoyed with him, his apparent passivity.

From the start she had believed Sam was not comfortable with Raine and yet . . . It would cross her mind that Sam was too final about things and Raine was the least final person she had ever met, always floating about, always throwing out ideas, never revealing who she was.

On the train ride from Paris to Antibes, a ride that had begun on a cheerful note, they'd all been in a buoyant mood; even Sam, who had not been in favor of changing plans, had privately told her that they would be better off going to Burgundy. But he had understood how much she wanted to join Ned and Raine and, despite his reservations, he had agreed to go to the Riviera.

She hadn't had much time to talk alone with Raine, and Lia thought the train ride from Paris to Antibes might be the best time to do so. When she found herself sitting next to her in their musical-chair-type of arrangement, she attempted to swing the conversation in the direction of Raine's childhood in San Francisco. So intent on finding out about Raine's life, she barely glanced as the train passed the verdant French countryside, barns, cows, and horses, which all seemed to blend into one swirl of color; it was difficult to differentiate between an animal, a human, or shrubbery. Raine, sitting next to a window, her hand cupping her chin, had viewed it with an intense absorption that Lia had only witnessed in a child.

She heard the dryness evident in her own voice when she mentioned to Raine that she seemed to be enjoying the view. Raine abruptly turned to her and looked embarrassed, though

briefly. "It is nice, Lia," she said simply. "Just trying to fill my mind with thoughts other than ones that are pressing,"

"I imagine you mean your work, not a subject to mull over while traveling."

She nodded, but Lia saw how she stared into her eyes and felt that she had revealed something about herself to Raine, and had no sense of what it was. She thought she'd been pretty straightforward, bland almost. Yet she knew she was not able to determine how Raine's mind worked.

Her voice firm and crisp, Raine responded, "I am happy you and Sam are coming to the Riviera with us. If you don't like it, you can take a train to Burgundy and resume your trip as planned. I hope you are honest about it. I do not want you to stay if you think it is awful."

Lia said, "I am glad we are going with you to the Riviera. It will be good to get to know you and Ned, even if we do not meet again." Believing she sounded presumptuous, she stopped herself. But weren't her words in the spirit of the moment? Yet she refrained from continuing on with Raine in this way.

Raine's expression seemed puzzled now, Lia thought, but she soon realized that Raine was pondering something else. She mentioned a movie she and Ned had recently seen that had been set on the Riviera.

Lia had viewed the movie too but had not reflected much about it. Sam had been away on business and she had seen it with a friend, and they had talked about other things that had been diverting them and had not paid much attention to the

movie. She told Raine that all she had surmised about it was that the characters, their actions were not congruent with the beauty of the Riviera, they seemed in opposition to it.

After mentioning this, Raine smiled broadly. "Yes," she said, "that is exactly what Ned thought." Then she stood up and although the train was proceeding at a furious pace Raine remained steady on her feet; with ease she called over to Ned to come and talk with Lia about the Riviera movie since they both had said the same thing about it. He was standing and talking to Sam. He turned his head just before he heard the sound of Raine's voice, as if knowing she would call out to him.

From time to time an image of Sam sitting with Raine on the train will come to mind, how if she turned her head slightly, she could not help but observe them. Whenever she did so, she noted their expressions; Raine, looking away from Sam, appearing tense, not at ease as she usually seemed.

Lia's thoughts of that time will ricochet from one memory to the next, all rich and nuanced, but what is different is that her memories are contrary to her usual manner of thinking; there is no order in her recollections of the trip. The whole experience is a dream to her; it is as if she never has fully awakened from her sleep on the bench that night in Antibes and has continued to live these past two years in a stupor. Oh, yes, she will conduct her class and go through the day-to-day activities of her life, but she is not the same; she has changed in some way.

Lia will often conclude that Raine is similar to either a restive child or an old woman who has experienced a dark and erot-

ic life. And she'll think again of Shirley and how a year after she had joined the group she had revealed to them that her mother had worked for an escort service in New York. Shirley's disclosure seemed to bond the five of them. For from then on, in their presence only, Shirley would be little less detached, more free, if only briefly. Though now Lia will wonder if Shirley's mother did work for an escort service or if instead she was working on her own, and her daughter had witnessed more than she should have. To lessen her disillusionment, Lia will think that it is because of Shirley that she prefers Gauguin; she finds the same detachment in the eyes of his women subjects.

She and Sam have met with Ned and Raine only four or five times since their shared experience in Antibes. Their dinners together have been inconclusive, not satisfying—they'll part with a sense of something missing, something unknown. Her awareness—at times nearly clairvoyant and at others irksome and vague—that something is missing is what Lia holds on to; she's hopeful that one day she will realize what it is.

32

Sam strides down Boylston Street. A brisk late October day, the sky is clear, a medium blue color, a shade darker than his eyes. He circumvents the small crowd of people milling in front of a trendy restaurant. As he crosses Arlington Street, his pace lessens some, and passing through the Boston Common he slows to a stroll.

Thirty-five in a month, he is marginally slimmer, the lines at the corners of his mouth are now defined, his eyes more curious than in the past. An expression of irritation no longer crosses his face. Or if it does, it is muted, nearly unreadable. When he smiles, the contours of his face appear less set, not more so as before.

Lia has asked to meet him on Washington Street, in front of the Jewelers Building. He's preoccupied with the spirited argument he just had with his father, whose company Sam now owns. Thoughts of meeting Lia and his discussion with Jack only minutes before crisscross his mind, veering off from each

other, preventing him from fully focusing on either his wife or his father.

Although Jack surprisingly granted Sam full control and ownership of the company five months before, his father will show up in the office when least expected, as he did today. Jack's expression was warm, inquisitive, his eyes darting as he asked about sales for an instrument he had designed, detecting non-ferrous metals.

Sam is well aware his father is not inclined to retire; Jack is developing another company. In terms of the company that is now Sam's, that Jack continues to keep on top of—sometimes his father's concerns are real and at other times they are part of Jack's imagination, the negative side of it. What could go wrong next? Sam is angered by Jack's persistence, but having worked alongside him these past two years, he has learned more about his father's idiosyncrasies.

When pondering his parents, he'll always be conflicted; he'll wonder what their existence would have been like if he had not come into their lives, and then for a moment he'll be filled with angst. To distance himself from this feeling, his thoughts will quickly turn to the business developed at first under his father's auspices, and now under his own direction. When interacting with Jack, Sam has learned to be rationally defiant. Though Jack never expresses defiance at all; his is held in, invisible—first and foremost, he is astutely logical.

Sam's cell phone beeps—a text from Lia; she will not be on time, will meet him thirty minutes later. He recalls the tender

look on her face this morning. She was up before he was. When he awakened, she was standing before the full-length mirror in her silk slip, applying makeup, the bright morning light caressing her neck, long for her height. In the past few years, he doesn't recall her putting so much emphasis on her appearance, can't remember when he last saw her applying makeup. He wonders what is on her mind, why she wants to meet him downtown on a weekday afternoon.

He stops, assesses where he is. He checks his watch; he is early. He looks about, trying to decide how to occupy himself for forty-five minutes. He could return to the office but most likely Jack will still be there and they need space from each other now. His father still appears smooth, fast-moving, adroit, but Sam comprehends that Jack is aging—it is in his eyes, more of a faded blue now. Yet Jack's gaze remains rounded, encompassing. He has not lost his robust intelligence; he refuses to do so. Sam knows his father will never rest, will not slow down for a while now. He thinks of his mother, Naomi, the reader, and, though conflicted, he smiles; she is both persevering and absent-minded, like a professor, who is both liked and endearingly joked about by her students.

Crossing Tremont Street, Sam notices a café that has been open for years. He and Lia have been there a number of times. He sends a text message to Lia, tells her where he is, and that he'll wait for her inside; it isn't far from where they were planning to meet.

At the counter, he orders a coffee and a croissant and is giv-

en a slip of paper with a number, seventy-eight. He finds a seat and takes out his phone, checks his email, hopes there isn't one from his father continuing their discussion of twenty minutes before. He becomes interested in a news article, and while reading it, nearly forgets where he is. He hears "seventy-eight" called out; he looks up—by the weariness in the boy's voice, it sounds as if it has been repeated several times.

Sam abruptly stands and goes to the counter to pick up his order and as he makes his way back to his table, he notices someone coming through the door—his face turned away, the posture is familiar, the slight slope of the shoulders, the strong torso and the surprisingly narrow waist; he hears the voice, both distant and warm. With a start, he realizes it is Ned. He considers calling out to him. If he leaves right away, he might not say anything; Ned may be in a rush. But soon Ned turns and gazes about the room, looking for an empty seat, and as he does so their eyes meet. Sam, standing close to his table, beckons for Ned to come and join him. In that careful way of his Ned nods in recognition, his smile broadening as he approaches Sam. He likes Sam but has reservations about him for reasons he cannot articulate, even to himself.

They have not seen each other in six months, and as they gauge each other they are reminded of how the last get-together had gone. Sam recalls Lia and Raine having a discussion about whether or not to have children; it had turned rather heated. Sam does not know if Lia and Raine have communicated since. Sam remembers that Ned had been preparing to write an article

on gold, and that he was uncertain whether or not Ned wanted to know his opinion, which Sam had freely given. They had parted that evening strained with one another.

As they speak in generalities now, they privately assess each other. Sam thinks Ned has lost weight, the expression of detached acceptance is no longer there—his face is more angular, more probing. He appears more independent. And Ned regards Sam with curiosity. He no longer seems overly confident.

"When was it that we last saw you and Lia?" Ned asks, turning away from Sam's direct gaze.

"April, I think," Sam says and shrugs. "Anything new in your lives since we last got together?" He's thinking that Ned seems very different from when they first met a little over two years before. Has he been slowly becoming this other person? He thinks of Ned, his confusion at that time, how he had hastily thanked him for locating Raine. At the time, it briefly crossed Sam's mind that maybe Ned had not wanted him to find her. And he remembers how Ned allowed him and Lia to go forward and search for Raine; the whole episode was surreal. But now, gazing into his eyes, a deep brown with a hovering sensitivity, a milder detachment, he is reminded how Ned had hugged Raine so closely and how he'd had tears in his eyes when they embraced after she'd been found. Then he remembers the four of them in the lobby of the hotel falling into one another's arms, exhausted from the experience as if they'd bonded in some way.

Sam thinks how unusual it is that he's never thought of that moment again until now. When they meet for their occa-

sional dinners, it is as if he and Lia are with a couple they have been acquainted with in recent years, whom they like and feel to a degree compatible with but don't know in any great depth, and do not have any desire to. It is as if he and Lia have blocked the memory of Raine's disappearance, and have chalked it up to bad luck as it lasted only so long and she had, after all, been found.

They blocked the experience from their minds, had not wanted to think about it too much, the ruse about a man with a gun. It was awful for each one of them to consider that something could have gone awry, that Raine could have been hurt, or that she had been in any danger. Yet there was the question that each one of them submerged and didn't want to admit to, did not bring up and discuss with any one of the others, only within themselves: Why had Raine gone off on her own like that in the early hours of the morning in a city she was only somewhat familiar with, where there had been a series of recent hotel break-ins? But then again, they each would push it aside and think they were giving too much attention to it—it really wasn't that important, there could have been a myriad of reasons, innocent ones.

Sam and Ned face each other over two years later and though these thoughts run through their minds, neither of them speak of them. Instead they converse about their work. It strikes each of them that until now, they have not been together without either Raine or Lia present.

"Do you still like working with your father?" Ned asks, grinning, thinking how it would be impossible for him and his father

to work together, not only because they are not in the same field, but because of their temperaments.

Sam's eyes light up. "Well, he handed over his company to me—it happened a month after we last met. He's planning to start up another one. He has lots of energy, and still likes to keep tabs on what I'm doing, how the company is progressing. Many people of our parents' age are addicted to their work, can't separate themselves from it." He watches Ned, who seems to be absorbing his words. "What about you, Ned? Are you still writing about international matters?"

"Yes, to a degree, but I am toying with the idea of writing political opinion pieces."

"I thought you were opposed to writing articles like that, thought you don't want to be pigeonholed, that you prefer to appear unbiased."

"Yes, true, but I've been too cautious and maybe I am no longer so. I think that incident we all shared in Antibes caused me to be less circumspect about things, and I have become more determined, I think."

"We both have gone in different directions than we expected when we first began traveling that summer; it must have affected each of us in one way or another. To be frank, I was upset with Raine for disappearing; I thought she wanted to spoil our trip. I look back on that time with anger—but on the whole I am a less angry person, I believe."

"I understand," Ned says, thoughtfully.

"Thank you for not taking offense," Sam answers gruffly.

Ned briefly smiles. Then, after a pause, he continues, "You asked about my work. l have another project—my editor has asked me to investigate. I'll be flying out to San Francisco next week."

As Ned speaks, Sam acknowledges there is a warmth to him as well. Lia likes Ned, feels comfortable with him, feels he is honest, though she was upset at first when he didn't seek out Raine when she was missing. But later, she attributed it to his state of shock at the time; she forgave him, graciously erasing from her mind the noncompliant Ned. Though in the past, Ned's duality has caused Sam to question him, particularly in respect to Raine; he has trusted him less than he should.

"San Francisco—do you often go there for your work?"

Ned clears his throat and looks directly at Sam.

"Ah, yes—isn't San Francisco where Raine was born and lived when she was young?" Sam asks.

Ned nods, then sips from his coffee. Putting down his cup, he says, "It's pretty complicated, not my news to tell right now. I need to investigate more—pulling up facts from the internet for the editor is no longer helpful." His voice is beseeching, his gaze impassive.

Sam smiles, then gazes out the window and across the street at the fallen leaves in the Boston Common—a blending of red, gold, and orange, the afternoon light highlighting the colors in some spots and in other places blanching and softening them. He feels an ache; he has a certain compassion for Ned, despite everything. Ned tries, he thinks.

"Not to change the subject," Ned says cautiously, "but I've always wondered if you knew Raine once, before we all met."

"I might have seen her in passing, probably in Cambridge whenever I would go to meet with a client or Lia and I would have dinner, but I am not sure. There has always been something familiar about her. But there are certain people who seem familiar. I think it is because of their expressions—open, vulnerable." As Sam speaks, he feels a tug of guilt—he doesn't want to be disingenuous with Ned, but he does not know what is true.

Ned shrugs. "I guess a good number of people may seem familiar in one way or another."

"No worries." And as Sam says these words he remembers Ned saying them in the small park in Antibes as he and Lia went off to find Raine, Ned's face nearly hidden by the darkness. He remembers because how odd, he had thought, those words coming from Ned's mouth, surrealistic, dreamy, "No worries." What a thing to say at a time like this, he had thought. And what was more strange was the expression on Ned's face, as if he were reaching for something that was not quite there. But now, today, Ned appears to be a different person, or at least a changed one.

Sam thinks of Raine, and the woman on the beach. Are they one and the same? It comes to mind what she told him at the time—maybe even Raine or this other woman hadn't realized what she was saying, maybe she could only acknowledge it be-

cause she was drinking, maybe she doesn't even recall it today, maybe it was an exaggeration, or an invention.

Sam lifts his head and sees Lia walk in; she catches his gaze and smiles in a distracted way. She has not yet noticed Ned sitting across from him.

33

A branch with red-gold leaves brushes against the pane; the swishing sound catches Raine's attention. As she looks up autumn sunlight streams in, illuminating the sketch she's been working on—a koala bear holding a lollipop. She never liked the look of a koala bear and doesn't see any connection between a koala bear and a lollipop. But she needs to accept any work that comes her way.

She drops her charcoal pencil onto the desk. Rising from her seat, she decides to take a walk. As she puts the key to the apartment in her jacket pocket, her cell phone rings. She sees her mother's name and hesitates before answering it. Dania must be worried about something, she concludes. Restless from working on the sketch and more uneasy than she's been in a while, Raine wonders if it may be better to talk with her mother later. Before the call is sent to voicemail, she reflexively answers the phone.

Her mother sounds irritable, her voice scratchy; she asks Raine if she is busy. She sounds almost hostile, Raine thinks.

"What is on your mind, Mom?" she asks pointedly. She is thinking again about the deadline to send in the sketch. She does not want to lose the client. Her eyes wander over to her desk and the sketch pad on top of it; she is disheartened. And that her mother is hesitating—almost in an argumentative way—concerns her.

"What is it, Dania?" Raine asks. Calling her mother by her first name is her way of maintaining a distance so that she can assess Dania's words. Though Raine perceives there is a change in her mother now—she feels a premonition, of what, she isn't certain.

"Has Ned left for San Francisco?"

"No, in fact, he hasn't—he is planning on going at the end of this week. I told you he's working on a piece for the newspaper. Why should this worry you?" Raine asks. She is exasperated now. Though talking with her mother has helped her become more like her old self. Dania has not before involved herself in Ned's comings and goings, especially regarding his work.

"Where will he be staying?"

"I don't know. He'll find a hotel on his own or the newspaper editor will choose one. I am confused. Why are you bothered by his going to San Francisco? It isn't like you."

"Will you be going with him?"

"I don't know—we have not discussed it."

Dania doesn't respond. Raine hears a clicking sound; her mother must be tapping her nail against the back of her phone as she does when she's impatient.

"Mom, you seem out of sorts. I was about to take a walk. Why don't we meet and have lunch? I haven't seen you in a while. We can talk then. I think there is more on your mind than Ned's trip to San Francisco."

* * *

When Raine walks into the café, she is surprised to see her mother looking tired and nervous, sitting at a table with her hands clasped. There is a heaviness in her expression that discourages Raine. "You are not yourself," Raine says firmly, raising her hand to catch the attention of the waitress as she sits.

The waitress comes over to the table; she is exotic-looking, thin with short hair cut at an angle, her brows are thick and dark and her chin is very narrow. "Hi ladies," she says, her voice is deep and mellow. "Would you like what you usually have— Raine, a tuna melt and Dania, an avocado BLT?"

They nod, and Raine asks for a glass of Chardonnay.

"Merlot," Dania says brusquely.

Once the waitress leaves, a purposeful expression crosses Raine's face, which causes Dania to think of her late husband. She frowns. The memory is not a good one; whenever he wore that expression, he would relay information she was not very happy to hear. She recalls the evening he told her he would be

going with friends for a few weeks to Europe to scout out more sculptures. She was furious. She would have liked to have traveled to Europe instead of staying at home, looking after three children. Though she would not have enjoyed a two-week separation from her young offspring. She studies Raine. She is convinced Raine is more like her father than she is like her. Dania would have preferred it to be the reverse—she is both more connected and more disconnected to Raine than to her two other children.

Raine, cutting into Dania's thoughts, asks, "Why are you so curious about Ned's trip to San Francisco? I've not known you to ask much about his work; I realize how strong your disregard is for his profession. You say it is the last career path you would have chosen."

Dania shrugs; her expression is sad, vulnerable, and Raine thinks she has been too forceful with her mother. What if she is curious about Ned's trip to San Francisco? Isn't it natural that she should be—that is where she lived with her husband, where her children were born. It strikes Raine that her mother has not been out there for years, maybe she never returned since they left. She isn't certain; she's lost track of her mother's travels.

"Is it because San Francisco is where you lived with Dad, where your children were born?" Raine asks, her voice sensitive. She reaches across the table for her mother's arm, holds on to it. "You haven't spoken of Dad in years, but I imagine you think about him nearly every day."

At a loss for words, Dania eyes her daughter and thinks

about her own life and how different it has been from Raine's. Raine has always stayed with what is familiar and she has been more adventurous than her daughter; she has always done what was necessary. Raine has no idea of what is or is not necessary. She understands her daughter is now settled in her life with Ned. Dania knows Ned wanted a child. Her daughter is an interesting woman, somewhat enigmatic, and she wonders how deep her awareness is of their life in San Francisco all those years ago. Or maybe Raine is more aware than she believes, maybe her understanding of those years is deeply ingrained—she studies her daughter, who seems more confident today than she has in the last few years, and wonders if it is only momentary.

"Yes, Raine, I do think of him but not in the same way. Our life was not easy—there was more going on than others realized."

"Oh, Mother, you like to speak in generalities, those that I find not particularly engaging or even marginally true."

"Yes, Raine, you have been much more literal than I—to be honest I cannot view anything literally anymore. Life becomes more and more complex on a geometric scale, not in a slow and steady way."

"What are you trying to say? I simply want to know why you are concerned about Ned's trip to San Francisco. It's not like you. You've always given us freedom."

"Raine, darling," Dania answers, a wistful expression crossing her face—there is no one she loves more than Raine. She knows it is not right that she doesn't love her three children equally, but she has accepted this reality for many years. The

other two have their own lives, do not want any interference from her; they do not need her as much as Raine does. She shrugs, then continues, "Yes, it does bring back memories and not the pleasant ones. I don't understand why Ned going out to San Francisco disturbs me. Does he intend to look into Edward's relations?" She presses her finger against the table, her face reddens.

"I don't know specifically why Ned is traveling to San Francisco. He is a journalist, and his editor has asked him to go. I know he is attempting to set his own course, ignore and not be held back by his father's words. He wants to be the journalist he believes he was meant to be. I do not believe it has anything to do with Dad's family or Dad's life."

Dania nods, smiles slowly, warily.

"Is there something I should know about? I believe it is very important to know the truth."

"You say that, Raine, but you tend to look at life in such a black-and-white way; it is difficult to discuss things with you in any depth."

"Am I not inquisitive enough?" Raine asks. She is annoyed and anxious.

"I honestly don't know." Dania takes a sip of wine and as she does so, she takes a quick glance at her daughter.

Raine looks quizzically at her mother. "How did the conversation take this detour? I wanted to know how you are; you seemed upset when we spoke on the phone. I thought you needed my advice. What is it, Mom, what is on your mind?"

"Do you think Ned is curious about your father, his family in San Francisco? I've always wondered about my going to San Francisco as a young person, falling in love with your father. I am pleased I followed my feelings—I wouldn't have had the three of you. And my understanding of Ned is strong, I mean, his purpose. He is different."

"Yes, Ned is more objective than most."

A friend of her mother's, who has been sitting at another table, comes over to talk to Dania. Raine half smiles, relieved that the conversation has come to an end.

34

Ned is the last passenger to board the plane. Now seated, the doors of the aircraft are not yet shut. It strikes him he should have invited Raine to join him. He's been preoccupied the past few weeks with setting up interviews he needs to conduct in San Francisco, and it did not occur to him ask her. Raine's presence may be helpful for many reasons, and after all this time, it may be beneficial for her to return to the city of her birth.

When he left her a few hours ago, he couldn't tell whether or not she was looking forward to having five days to herself. She hadn't asked to come—if she had, Ned would have been pleased; he would have explained that he had some research and a certain number of interviews to do, but that they would have time together in the evenings. Maybe she could show him around, whatever she remembers—if anything—about the city. He finds it odd they never went to San Francisco together, and that Raine has not visited the city since she left as a child. He attributes her not doing so to her mother, her influence on

Raine; these past two years he has become more and more wary of Dania.

Lately, Raine has been more quiet than usual, and he is aware it is because of his guilt that he now wants Raine to come to San Francisco—ever since she disappeared from the park in Antibes nearly two and a half years ago, he's been careful to not be drawn in by her. The experience has changed him—he's become more dispassionate toward her. She was shaky and withdrawn after she'd been rescued, having looked at him with a pleading expression. To this day he does not comprehend why she left the park alone in the early morning hours; it was dangerous, and he'd not known her before to take risks—she's spontaneous, yet cautious. Something must have come over her; he cannot fathom what it was.

He considers sending Raine a text now, asking her to join him tomorrow.

Last night, over dinner, she asked him, her voice soft and crisp, if he would let her know if something came up during his time in San Francisco that was intriguing, that might interest her.

He looked at her and said, "Of course, Raine, but the reason I am going will not be of personal interest to you. It has to do with my work; the managing editor is sending me out there. There are a few ongoing investigations he wants me to check into. I will interview people. It may have a connection to a case on the east coast—all white-collar crimes."

Tilting her head to the side, she responded, "I thought you were only writing pieces on international issues."

"Yes, but it may all connect internationally—that is why the editor has asked me; if it doesn't he'll put another journalist on the investigation. Raine, I am also thinking of writing opinion pieces."

"Political ones?" she asked, smiling in a demure way. He's not seen this side of her in a while, he thought.

He shrugged and was noncommittal. She had come over and had thrown her arms round him.

And he recalls how uplifted he felt. Raine was always capable of making him happier than he thought possible, more open to her whims than he wanted to be.

Yet ever since their return from Europe two years ago, when he thought he could have lost her in Antibes, he has been more careful with her. Maybe he has been too much so, he thinks.

He reaches for his phone in his shirt pocket and then sends Raine a text, asking her to join him, if possible, in San Francisco tomorrow.

She answers almost immediately that she isn't certain she'll be able to pull it off.

He types that she can work in San Francisco—just bring it along, she doesn't need to be in her home office to do it, does she? Or is there another reason?

There is no other reason, she responds.

He waits for her to say more, but she doesn't.

He looks up and wonders when a flight attendant will instruct him to put his phone in airplane mode, but doesn't hear anything yet. The flight attendants are gathered together at the front of the plane, deep in conversation. He wonders if the flight will be delayed. He holds his phone in his left hand, waiting for Raine's response.

Ten minutes later she texts him to say that she has booked a flight, she will be landing in San Francisco at 11 p.m. this evening. Though he is pleased, he is uncertain how it will turn out.

* * *

Ned waits for Raine in the luggage area of the airport. It is after 11:30 p.m. and not many people are around. He sits on a plastic chair, his shoulders slouching, and checks his watch; her plane landed nearly thirty minutes ago.

He looks up; Raine is coming toward him. She appears tired. Her eyes widen once his gaze meets hers. But as they wait for her suitcase to come down the chute, he thinks she appears lost. Her arms are crossed and her eyes half-shut. He is gratified that she has come. He has an urge to pick her up and carry her to the car.

Although it is late, the traffic is heavy; Raine has fallen asleep, and glancing at her from time to time he thinks of how tired she was after Sam rescued her. How she's changed after that experience—firstly she is careful before she responds to a

question. Also, she doesn't throw herself into activities as she did before, and she is less earnest when she listens to others speak. In terms of their love-making, she is more yielding.

Ned acknowledges that in the past two years he has become more skeptical about life; his idealism, though stronger, is less forthcoming, more guarded. His relationship with his father has taken a turn; no longer is he either overly respectful, or immediately rejecting of whatever his father says; instead he has learned to question him in a thoughtful way, realizing that his father's words are more complicated, should not be taken literally, that he never expected him to do so.

In the hotel room, while Raine sleeps, he lies next to her, watches her breathing, more halting than before. Ned hasn't really studied her this closely in a long time, and feels a sense of loss.

When they returned from Europe that year, their life after a few months took on its usual rhythm. Raine became entranced with her drawings, exhibiting more of a sensitivity to her work than before; occasionally Ned would wonder if one day she would turn to painting.

Becoming more and more serious, maybe even strident, about his work, he stopped observing Raine, though he remained aware of any significant change in her mood.

His thoughts now become incoherent, swirling together; he's growing weary from the day and his pleasure at seeing Raine. Why did she not ask to come? Why did she so quickly join him?

* * *

The next morning they breakfast in their hotel room. Raine, in a white robe, eats in a halfhearted way. After a while, she raises her head and asks about his interview that day. Sunlight infuses the room. Ned cannot quite believe she is sitting across from him.

He watches as Raine looks about their room, her eyes fastening on a print of Klimt's most well-known work. "I've never really liked the painting but how the light brings out the gold in the print is enticing."

He nods and doesn't respond.

She turns away from the framed Klimt and asks again, more directly this time, who he will be interviewing. A ray of light falls over her eyes, lending a paler cast to them. She appears beautiful; he has never before regarded Raine in this way, more striking, energetic, but never beautiful. Maybe something is going on inside of her he's not aware of. He is regretful he has allowed his intensity about her to slip away as it has these past two years.

He meets her gaze—he realizes she's been observing him; he only vaguely recalls her question. He is more interested in knowing how she is—it is always the question he most wants to ask, but it is a question they shy away from. They speak of facts, thoughts, not their emotions, and he is not sure this is wise and has been less and less certain these past two years.

She must know he's forgotten; she prompts him. Lifting her

chin, she repeats her question, her voice even, a piece of toast in hand.

He smiles and nods. "I am not actually interviewing anyone specifically today—I need to do some research first, look up some old records."

"What is it you are investigating?" she asks, more upbeat now, curious.

"Did I not mention it to you?"

"Yes, but in a very general way. Now that I am here with you, I'd like to know a little more of the details."

"Why don't you come with me today, unless you have to work?"

"No, I have told the art editor that I want the week off, that I'd like a break, but I'll work once we are back in Boston, I'll need to meet a deadline."

Ned feels anxious for a moment; he's been a little less trusting of Raine these past two years. On her part she has not been less trusting of him, maybe more so. He chides himself for his lack of sensitivity to her.

He takes a sip of coffee, then says, "It has to do with a case that began years ago, and as I mentioned, there may or may not be some connection to an ongoing investigation in Boston. A money laundering scheme, perhaps with a link to the San Francisco area. If there is a connection, the editor will put more experienced journalists in charge of the project. If there is a European link, I will report on that angle of the case."

As he speaks she looks down at her phone on the table—or is it the food on her plate? He cannot tell. She doesn't say anything to him and he wonders if she is no longer interested, or if her attention has begun to wander.

When she looks up at him, there are tears in her eyes that do not fall to her cheeks or face. She looks at him steadily.

"Ned," she says softly. "It is difficult. I was born in this city and yet I feel so estranged from it. It is overwhelming."

He studies her, doesn't know what to say.

"I should not have asked you to come—you have avoided returning to San Francisco. I believed you would come if you wanted to. But maybe you knew it might be painful for you. I don't know—I am trying to understand." His heart races; he isn't certain he should say more.

She stands up, goes over to him; standing behind him, she places her hands on his shoulders and says, "There may be a reason I never returned. When I was in the room with the woman in the hotel in Antibes—remember?"

"Yes, of course I do—it was a horrible experience."

"I know, but I was found soon afterward, and when things are resolved relatively quickly, no matter how scary the situation is at the time, and resolved in a good way—no one was hurt—people forget about it. It doesn't seem that awful in retrospect.

"As I have said to you before, I said things to the woman, I spoke of things I had not before remembered. I was stuck in that room with this woman, who was both helpful and insensitive.

She was probably in as much of a state of disbelief as I was. Though she presented herself as practical and business-like."

"Yes, I understand," he says, feeling her hands pressing his shoulders.

"Ned, you know how I was when you saw me after Sam found me. I only half recall what I said to her. Hopefully it will come back to me; I only remember bits and pieces—scattered words, no complete thoughts. I try and try to recall but memory is elusive. I know I've said this to you before. But being here now, waking up in this city . . . I believe there may be more that happened when I was here as a child, even more than what I said to the woman, memories that are so deep and unreachable that I'll never be able to know, they will never come to the surface."

Looking over his shoulder, he catches a glimpse of her. The sun must have gone behind a cloud; the contours of Raine's face appear dimmer. He wonders if he's lost her. With a sinking feeling, Ned rises from his seat, turns and reaches out to her.

The Following Winter

35

A snowless January; it is the third week of the month and the cold has been deep, extenuating, a natural time for reflection even for those not inclined.

For most of his life Ned Lanier has straddled the middle ground between action and introspection; though he has become more ponderous this season—not only because of the biting weather but because of his marriage, his floundering relationship with Raine. During this unending cold spell, he spends much time in his office, refuses to take a lunch break, orders a sandwich from the cafeteria, avoids socializing with his colleagues. He doesn't attempt to return to their apartment until he is prepared to brace himself and face the dropping temperature.

It is not only the harsh wind and cold that prevent him from leaving the office earlier to begin the ten-minute walk to his car; it is having to speak soon afterward with Raine. He is not able to predict what her mood will be; she may be joyful, or hurt

by someone's words, or annoyed with him about some trivial matter—though that never lasts long—or mentally exhausted, which is more often than not the case.

Ever since their return from San Francisco in early November, Raine has been different. She is not facile enough to rebound from the hold her emotions have on her; her mood, whether sad or buoyant lingers—it is there and then, when least expected, it isn't. She is with him and then she isn't.

He wonders what may have occurred during those late afternoon hours in San Francisco when they were not together.

In the mornings he and Raine would enjoy breakfast together at the hotel. In the evenings, they'd go out to a restaurant, visit a museum, attend a play or concert. But each night she seemed further and further away from him, less definable—her pale green eyes becoming vacant, her nature more and more subdued. How much she was affected by being there did not dawn on him until their last night in the city. They were having a drink at the Top of the Mark; looking askance at her, he asked, hoping to pry her from her silence, "Are you thinking about nothing?" He was attempting to joke with her; though to him, his voice sounded weak.

She didn't smile or look at him in that provocative way of hers—she answered, "I wish I could, Ned."

As she spoke, she followed his eyes as if she were cutting into him to blunt his spirit, his hopes. And he felt a shock within; this wasn't the Raine he'd known for over fourteen years. He turned away from her.

After a few minutes, he looked over; she was staring out at the view of San Francisco Bay, but she was expressionless and it was as if she were not really looking at what was before her, comprehending its elegance. Her fingers, cold at first, pressed his wrist. He remained quiet and felt his pulse quickening.

"Ned," she spoke quietly, still looking away, her voice seeming in the distance, "do you believe it is possible to transcend a bad, no, I mean, a devastating experience?"

He felt his pulse slowing; he knew he needed to be careful in how he responded. His first inclination was to say in a practical way, "Yes, you can, I suppose, with a good therapist." But he knew that would not appeal to her. His second thought was more broad and much less definitive: "Only if you want to, Raine," he could say, but again those words would not comfort her, would make her more uneasy. And so he remained silent, not knowing how to answer; he didn't want to discourage her. Then it came to him; he turned to her and asked, "Do you have a devastating experience in mind? You have never mentioned one to me—yes, you have spoken of unpleasant experiences, sad and scary ones, but I do not recall your speaking of an incident that you or I have thought of as devastating."

"I know what you are saying," she said, seeming more present now.

She was like a rotating light, her presence more apparent at certain moments than at others. He felt her hand clutching his. "The problem is I believe I may have had a devastating experience, but I am not certain what it was."

"If it is something you think, not something you know, it did not happen unless you remember exactly what it was, the time, the place . . ."

"Yes, I agree with you, Ned." She got up from her seat and said in that old provocative way of hers, "Let's go back to the hotel."

* * *

Once they returned to Boston, the managing editor called Ned into his office and said he had received the information Ned had sent him and had determined there was no connection between the money laundering scheme in San Francisco and one in Europe, and as there was no international component to the project, there was no need for him to work on it. He personally disagreed with the editor's assessment, believing that the situation in California had not yet been examined thoroughly enough, but, on the other hand, he wasn't interested in producing a story on white-collar criminals. He found the whole topic distasteful, not forward-looking. He refrained from giving the editor his opinion. Instead, he put his hands in his pockets, shrugged, nodded, and walked out of the office.

At his desk these long, cold days, he has been working on his own project. He is hoping to prove, probably mostly to himself, that he is able to be a dispassionate political journalist. Without an inkling of bias—if it is possible, if it is even wanted or needed.

He wonders if being devoid of bias is as nearly impossible as it is to think about nothing. Standing, he reaches for his winter coat on the chair next to his desk; extending one arm and then the other into the sleeves, he buttons up and prepares to face the cold outdoors. As he leaves the building, he is hit with a rush of wind and frosty air. The street with its few naked trees appears stark and there are no other people out at this time. Taking long steps, he makes his way to his car, his hands in his pockets, the collar of his coat turned up to cover his ears. He imagines Raine greeting him with that disconcerting look in her eyes, a look he first noted when he first saw her after Sam had found her locked in the room in the Antibes hotel; over the past few years, it has surfaced from time to time, becoming more pronounced and nearly constant since their trip three months ago to San Francisco.

To divert herself, Raine has begun painting with watercolors—landscapes, houses, people. Whenever Ned observes her, he notices her posture is not like it is when she is drawing cartoon or animal figures; instead she hovers too close to the easel as if she is attempting to pierce through the paper with every stroke.

36

Lia, three months pregnant, gingerly touches her stomach; she doesn't show much, if at all, but she is very aware of this other life within. She tries to imagine what the baby will look like, which one of them she will resemble. It is easier for her to say "she" as Lia believes it may be a girl, for no particular reason—she has never had a preference. She supposes she is assuming it is a girl because she has two sisters; it is what she is accustomed to.

She sits in the sunniest room of their home; it is an afternoon in the last week of January, and the light is even stronger today, reflecting off the pure white snow that fell this morning, only three inches, a surprise. She likes to spend quiet time with herself, though she never has before; it is more a result of her physical condition than because of the weather. She needs to be careful, to adjust.

Sam insisted on purchasing a home a month after she be-

came pregnant. She is surprised he possesses a nesting instinct; she would not have guessed this about him; he has always appeared indifferent to anything other than his own world and their world as a couple. As he is an only child, she has always understood his inclinations, and at times wished her life could be so focused, but as the oldest of three, she will never have the freedom he has to be himself.

Their home, a two-story colonial needing some work, is just outside the city limits, in a not too placid suburb. They moved in at the end of the past year, she has enjoyed decorating it and thinks Sam has derived more pleasure from doing so than she has. She misses living in a city; her commute to work is longer, and going in to the school each day, teaching her class, is becoming more and more tiring. The baby is due in early July; she is hoping to leave work by the end of May.

Having a child was not in her more recent plans, and so she feels both pleased and a little startled at the same time. Her pregnancy was unexpected in that she had had a few miscarriages and assumed it would never happen.

Lia knows she has always wanted to travel along one lane in her life, not veer off of it, but things never seem to work for her in this way. And now she is off course not because she never planned to have a child but because it didn't happen as planned. Her plans have come into fruition so late, the whole experience does not seem quite real to her.

Each day when she returns from work, she'll sit alone in

this room while Sam is still out and muse over how one's life can change. She will think that maybe her reality is more unpredictable now than it was when she was a young girl growing up in Richmond.

She cannot imagine Sam as a father; he is too exacting about things, and is not very flexible except when it comes to her. She worries he won't be warm enough with the child because in his strictness there is a detachment—he draws away from her when he is in such a state, not wanting her to see that side of him.

She smiles to herself. Does he not realize after just fourteen years of knowing him she will never be disturbed by him, his behavior? She comprehends how soft he can be, despite his firm demeanor. She understands he will always defer to her. She's just hoping it will be the same with their child.

Lia thinks of him in Antibes, how determined he was to find Raine; although he didn't particularly like her, he knew she was attached to Raine, wanted to get to know her better, and so he did his best. Lia smiles and again touches her stomach. She feels a sense of contentment and security she hasn't felt in the longest time, maybe ever.

Her thoughts wander to Ron, how she had desperately and knowingly wanted to have an affair, and how disappointed she was when she discovered he had moved away. She recalls banging on the door of the music office when she thought no one was in the area, but soon she felt someone behind her; when she turned round, no one was there. She remembers the last

time she had lunch with Ron, how he had lingered close to her as they walked out of the diner; there was really nothing more to say. He'd be spending time with his family on Cape Cod that summer and in a few weeks' time she'd be going to Europe with Sam. She recalls how their hands touched as they walked close together and how when they reached her car, parked now in an almost deserted lot, his was the only other vehicle there. The school year would be ending in a few days and no other teacher or administrator had wanted to be at the school at this time of year; they were all looking forward to the end of the academic term. She was the only one who had no desire for the school year to end, despite her discordant class. Ron had slipped next to her in the car and put his arm around her. "Good-bye," he said, and leaned over to kiss her, a kiss more passionate than she would have expected, his hand touching her breasts. And before she knew it, he was gone.

She closes her eyes, the sunlight bathing her lids; revolving images cross her mind, Sam and Raine sitting together on the train to Antibes, Ned, in Antibes, on the bench, refusing to come with them to search for Raine, Ron's expression before he leaned over to kiss her, she and Sam in Maui, her friend Shirley. They had met Raine and Ned in Europe and then their life seemed to change. Yet she still had gone to Ron's office the following fall; she wanted to let him know it was over although it had not really begun. Soon she falls asleep.

37

In a sheer nightgown, Raine lies on her bed. It is four o'clock in the afternoon, and she feels dazed; she turns her head, gazes out the window; through the slats in the blinds she sees it is lightly snowing, the white flakes falling gracefully—deep within she knows there will be better days.

Ned is at the office—he is away many hours each day—and she is discouraged. She has felt lost since their trip to San Francisco three months before. Since their return, every day has seemed endless, and the horribly cold weather these past six weeks has added to her sense of restlessness and unease. She fleetingly wonders if Ned doesn't like to be with her anymore. From time to time he'll ask her if she is hiding something from him. Of course not, she will respond, willing her voice to sound strong—though it never does.

Raine believes he is wondering what she did those late afternoons in San Francisco while he was conducting interviews

and is convinced it is what he is referring to whenever he questions her.

During those late afternoon hours, she would go to the residence where she lived as a child. She'd stand on the sidewalk across the street and stare at the home. It was painted a light green color and it was located on a steep hill. Her mother had shown her photos of it some years before. In the pictures it was brown and beige, and this new color gives it a lift.

She would stand and wonder what her life had been like in those days. As she stood with her arms crossed, it was difficult for her to penetrate her memory; there were so many layers. She felt blocked, as if instead of observing a home, she was staring at a blank wall. Her frustration grew each day; she could not recall or imagine her life as a child living in that structure.

She had been four years old when her father passed, and she was told he became very ill in their home, but she doesn't remember any details. All she recalls is how upset her mother was a year or so later, and her brother who was older than she was seemed to be in a state of disbelief, but once they moved to Massachusetts he seemed to forget about it. Her younger sister had been much too young to remember anything; she'd been only two years old.

Raine gets up from bed and goes to the mirror, studies herself, and then she wonders, as she has since meeting Sam and Lia, whether she knew Sam in the past in some way, but she cannot fathom how that would be possible. Her life has been

pretty straightforward. Where would she have seen him? He does seem familiar but she is unsure, so uncertain whether or not she met him before. There are moments when she honestly believes she has—was he the man she spoke with in Florida some years ago, but no, Sam's demeanor is very different. It is impossible she knew him the past, yet there is a strong connection between them; it disconcerts her, it isn't what she wants to ponder now—there is so much more. Yet she fleetingly recalls the moment Sam rescued her; there was an intensity in his actions, though at the time she had been in a state of panic, she hadn't even noticed his expression, but it comes to her now. She does not wish to dwell on that time in Antibes; it was unpleasant. Ned didn't seem like himself and though she could see how Sam and Lia approved of his joy, his relief in seeing her after she was rescued, his deep emotion, she thought there was something missing.

She hasn't been receiving very much freelance work lately; her heart isn't in it—she wonders if she is losing her desire to create.

Leaning in closer to the mirror, she sees in her eyes a haunted woman—but what is she haunted about? It is a mystery, and in some way she thinks it connects to Sam, but does it? Or is she putting it on him because she likes Lia and he is Lia's husband—a scapegoat of sorts? And though she and Lia do not always see eye to eye on things, she does value her friendship; Lia is a solid person and that is what she needs most in her life right now.

Ever since she and Ned returned from San Francisco, her

mother has been acting strangely. She does not return her calls promptly as she has int he past. And she has never asked her about her trip or if Ned's investigation was successful. It really is unlike Dania, she thinks. She goes into the kitchen to make a cup of tea. She feels a draft of cold air and goes back into the bedroom, pulls out a sweater from the closet. She draws it close to her frame and feels warmer. Returning to the kitchen, she puts on the tea kettle.

She thinks again of San Francisco, how she stood outside her childhood home and closed her eyes, wishing she could remember, but the past seemed so distant and unreal to her. She always has been a person of the present. The present is becoming unsatisfying to her—a commercial artist is very much in the present; it is the present that counts, capturing the given mood of the public, creating a drawing that will be appealing. There is no depth in it, and she acknowledges that she has always decried depth, its connection to the past, the heaviness of peering below the surface. It prevents one from living, from enjoying the present, thriving in the present—it is what she has always believed. Though now she wonders if her belief system may have been faulty.

Yesterday she heard from Lee, her ex-fiancé. He sent her an email and as she read it she recalled her mother saying he was a father figure—but that was fifteen years ago now—she can't believe all that time has passed. Tyler must be nearly twenty. Lee was contacting her because he was looking for an artist to do some work for him—he now owns his own advertising firm.

She didn't respond to him; she just deleted the email. What was he really looking for? She wondered. Because she no longer was passionate about her work, what help could she offer him, his advertising firm? He mentioned that he had retrieved her email address from an advertisement he'd seen of hers. At the time, she'd been desperately looking for clients. But she no longer is—it occurs to her that maybe she wants to do something else, something very different.

Her attempts at watercolor painting have been satisfying to a degree. She is aware that it is only a passing interest. As a hobby, maybe it will replace traveling—she and Ned have not returned to Europe since their experience in Antibes. The harsh whistle of the tea kettle catches her attention; unending, it seems, echoing how unnerved she has become.

38

Business is slow for Sam—many employees are sick with the flu, not able to come into work, and those who do seem discouraged. Every day he attempts to rally the troops, as he likes to say, but he doesn't seem to be getting anywhere. His father hasn't been coming by very much, if at all; Jack is preoccupied with building his new business. He seems to have forgotten about his son; Sam is half-pleased, half-annoyed. He likes his independence, being in charge, but at the same time his father is savvy and Jack's ability to quickly discern and assess a problem is what is missing in his company right now.

Despite the weather, he takes long walks during his lunch break. He thinks of Lia, her pregnancy, how content she seems, how the very slight edge in her has vanished. She's keeping a daily journal, something she's not been inclined to do before. As these thoughts pass through his mind, he also is reminded that he needs his business to run better for the sake of the child as

well as for himself and Lia; he now walks with more purpose, striding aggressively down Boylston Street.

The early February cold is biting, and he burrows through a strong wind. He decides to stop for a hot chocolate; the coffee shop where he first brought Lia has been gone for about five or six years now. He recalls another place, about two blocks away. A second draft of wind and his eyes fill with tears.

Once inside, he takes a deep breath, looks across the room for an empty table; finding one, he sits down for a moment to warm up before taking off his coat and removing his hat and scarf. As he does so, out of the corner of his eye he sees a woman who looks familiar—he wonders if it is Raine. Getting up from his seat to order from the counter, he walks by her table and feels a sense of anxiety; when he sees it isn't her he breathes a sigh of relief. He wonders why he should have been so anxious, and then so relieved. He isn't intimidated by Raine in the least, but she gets under his skin, he acknowledges.

* * *

This night he returns late from work. When he opens the front door, Lia calls out to him, tells him his dinner just needs to be heated. He goes to the threshold of their bedroom; she is lying on her back, her arms extended, her eyes drowsy, her lips full and despite her fatigue, she smiles at him. He moves toward her; lifting her hand, she says, "Have dinner first, Sam and then we can

talk." He nods and smiles and goes into the kitchen. It strikes him that Lia seems a little pale.

He opens the refrigerator, takes out his dinner. Turning away, he sees she has left a note on the counter instructing him on how to reheat it. He picks it up and follows her directions, always clear, always simple, always comforting.

While eating he looks about the kitchen. He's pleased they have purchased a home before the baby's birth; it is more comfortable, though he does miss city living to an extent—if he did not work in the city, he knows he would miss it more. The activity of a city has always been appealing to him—his parents never moved away. It is a different time now.

After he finishes, he goes into the bedroom. Lia is sound asleep. She is not completely covered by the blanket; it rests below her chest, and he sees how thoroughly she breathes. She is in another world. It is compelling for him to watch her. She has a very practical side to her as well as a wistful one, and it is nice to see her express a contentment he's never witnessed in her before.

As he gets into bed, he is careful not to awaken Lia. Lying on his back, he glances over; she is sound asleep, her lips parted, her breathing steady, purring almost. He wonders what she is dreaming of—their child or something, someone else? He does believe a few years ago she was interested in someone—it was close to the time when they met Ned and Raine and then that situation in Antibes occurred and she seemed diverted by that

more than anything else. At first when they returned home, he wondered if it was lingering a bit in her but then it disappeared and they went on with their life as if nothing happened, and maybe it didn't. Looking over again at her sleeping, he believes she has completely forgotten about it—it must not have been important or maybe it was his imagination. He has never thought of himself as a jealous person, but maybe he is. He trusts Lia—she is the only person he believes in.

He closes his eyes and soon he is asleep. His dream is not about Lia but about Raine. They are near water, and Ned and Lia are not in their presence. They talk for a while as friends; there is no tension between them, and in his dream he realizes it is because they have been drinking. Their words are slurred.

"I do not like how you look," he says firmly.

"And I do not like how you look," she answers, mimicking his tone. Then she begins to laugh, her voice not crispy but hoarse.

He feels offended. "Why are you laughing at me?"

"I am not laughing at you, I am laughing at myself."

"Why?"

"Because I know horror."

"Then why do you laugh?"

"Laughter helps."

"Don't talk of it—just laugh."

"But I do want to talk of it. Someone I know may have done something horrific."

"Horrific?"

"Yes."

"Do you mean this person literally did something horrific or did someone say something that was horrific?"

"Does it matter if someone said something or did something horrific? It is the same to me, the intention, the thought existed."

"What happened?"

"I can't remember now—it has slipped away."

Sam opens his eyes and wonders if in his sleep he was recollecting a part of his conversation with Raine—or the woman who may have been Raine some years ago?

One Sunday last August, he and Lia were strolling down Tremont Street and for some unknown reason he remembered most of his conversation with the woman who may have been Raine, and he shivered. Lia took his hand and said she wondered if he were coming down with a summer flu. He answered with a strong no, adding that he was absolutely fine. Though, a few months later, he spoke of it to Lia.

He now sits up in bed, drops his head into his hands, and asks himself: Was it Raine or someone who resembled her? The woman in the coffee shop this afternoon crosses his mind. Or was his reverie tonight, after all, simply a dream? And it strikes him that, like an obscure dream, it is no longer practical to ponder whether or not it was Raine—it is no longer relevant.

Many Years Ago

39

Richmond, spring, 1988: Vivian Marst, her four-year-old daughter at her side, strolls toward her friend's home, eight blocks away. She has mixed feelings about bringing Lia to see Fern, and is unaware she is passing her uncertainty on to her child.

Lia wears a pale pink dress, an A-line shape; she clutches onto her mother's hand—her new leather shoes are too tight. Her mother has her wear dresses only on special occasions and Lia knows this is not one; though young, she understands something is different and is confused.

Vivian, called Viv by those closest to her, has always prided herself on her open-mindedness, and though she has never regarded herself as perfect, in a moral sense—those wild parties during her college years—she believes in boundaries when it comes to personal behavior in people over twenty-eight; her friend doesn't. Yet, to a degree, she has accepted her friend's behavior;

Fern is divorced, has had a terrible marriage, and has a daughter, Shirley, who was born the same year as Lia.

Viv is disappointed in herself for insisting that Lia wear a dress. She has always wanted her daughter to feel natural and free; by having Lisa wear a dress, she believes she is protecting her daughter. It is Vivian's way of letting Fern know that she has boundaries, that she doesn't agree with her friend's lifestyle; she realizes it is an indirect way of doing so.

Fern plans to leave Richmond soon and move to New York. Viv can only imagine how she will support herself. Although her friend hasn't acknowledged it, Viv has a sense that Fern has been earning money in a questionable way. She has told Viv repeatedly that it is difficult to survive as a single mother. Vivian doesn't ask questions; she keeps her suspicions to herself.

Viv, grasping her daughter's hand, walks up the front steps of Fern's home—she is dizzy for a moment; it is early in her third pregnancy and she wonders if she should be walking on such a warm day.

Fern opens the door, and Vivian embraces her. "Are you okay? You look flushed," Fern says with concern, and steps back.

"I am fine—maybe a little water would be nice—it's awfully hot out there."

After Fern hands her a glass of water, the two women sit down and begin to talk. Lia still holds on to her mother's hand. Soon little Shirley comes into the room. Lia and Shirley have not met before.

Once she has been introduced to Shirley, Lia announces in a pointed yet calm way, "I want to go home."

"Be patient, honey," Viv tells Lia, patting her hand. Shirley wanders out of the room, and Lia edges closer to her mother.

An hour later, before Vivian has had a chance to tell Lia they will be leaving soon and that they should say good-bye to Shirley, Shirley comes into the room with several photographs in hand.

Abruptly Fern stands up, reaches out and takes the photos from her daughter. "Those don't belong to you, Shirley." Her voice is even, yet strained.

Out of the corner of her eye, Viv catches sight of one of the photographs—Fern, on a beach, topless, in the arms of one of the wealthiest married men in Richmond.

Not only does Vivian not visit her friend again—she neglects to say good-bye to Fern before she and Shirley depart for New York.

40

Ned is awakened by the sound of loud voices. Whenever this happens, he will go into his older brother's room. And his brother will instruct him to sleep at the foot of the bed. Then his brother will turn away from him and go back to sleep.

Ned experiences a certain comfort in his brother's room, that he has allowed him to be in his company, but he will never feel completely accepted by him—he understands it is because he is much younger.

On this night his brother is not there; he is spending the night at a friend's house—that is all Ned knows. He doesn't know which friend his brother is staying with. He cannot keep the names of any one of them straight. Ned has private names for them based on his impressions. One of his brother's friends always wears his baseball cap backwards, the other one winks at Ned whenever he sees him, and the third will keep his hands in his pants pockets, his lips closed, and never speak to Ned or even acknowledge him. He has heard the names Jason and

Juan and Edward, but he does not know which one is which, or even if the names belong to any one of them. His brother may be speaking of other children he goes to school with. It is a mystery to Ned.

The voices grow louder; he sits up in bed, rubs his eyes, not knowing what to do next. He feels a sense of fright—it is so dark— and he is not able to move. If his brother were sleeping in the next room, he would scurry into his room, holding on to his teddy bear. He looks about and waits; slowly it becomes lighter and he feels more comfortable, but then he hears the raised voices again and feels queasy inside.

He drops his feet onto the floor, feels the soft carpeting against his bare soles. He looks hastily around the room but he cannot spot his stuffed teddy bear. He closes his eyes for a moment and then opens them. He makes his way to the door, turns the knob, and then goes out into the hallway. He feels exposed but knows, despite how scared he is, that he has to discover what is happening. He has a deep need to protect his mother—he now hears her sobbing. It is not something she often does and so it is new to Ned. He tucks in his stomach—he believes by doing so he will become brave. Then he scurries toward his parents' bedroom. The door is closed; he reaches to open it, and when he cannot he begins to cry. Soon he sees the knob turning and when the door opens he meets his father's eyes, which have always disconcerted him; he cannot determine whether his father is a friend or an enemy, whether he likes looking down at Ned or does not find him pleasing.

Now he sees that his father appears calm. His father opens the door wide and Ned notices his mother sitting up in bed. She is smiling. She pats the blanket, a sign for him to come and stay with them. He hears his father say, "Ned must be having bad dreams again." Ned has heard them say this many times before but he doesn't know what a bad dream is. Was it a dream? Ned wonders and becomes terribly confused, yearning to know the truth.

41

It is late September and Sam, who will turn five in November, plays alone with his Legos. He likes to build things and hold the hard pieces in his hands, feel the edges. His preschool teacher has told his parents that he has very intelligent hands because he thinks with his hands. His father likes the teacher, but his mother believes she has jumped to conclusions; Sam is much too young for her or anyone else to know where his strengths will lie.

Sitting on the floor in his playroom, jamming plastic bricks together with as much force as he can muster, he is filled with a sense of authority. He is so focused that he does not hear the footsteps of his parents coming down the hallway. They are having a discussion. Sam is accustomed to hearing his parents mull over things; they usually speak in an intense though not unkind way to each other, and he has never heard either of them raise their voice.

When Sam looks up, he eyes his parents standing in the doorway, continuing their discussion. He points to what he has

built with his Legos. *His father comes over to him, stoops down to pat him on the back, and exclaims, "Great job, Sam!"*

His mother crouches next to him, picks up the structure he is building, holds it up to the light, turns it around to look at it from different perspectives, and says, "I see you like to use blue Legos more than the other colors, Sam." And then she smiles in a warm and distant way. Sam looks up at her with pure love in his eyes, but he is disappointed she doesn't touch him as his father has.

He feels his father lifting him up. "Sam, you will be coming with me to the cabin in New Hampshire this weekend. Your mother has a meeting with her agent, who may have a new job for her."

Sam isn't certain what his father means by a new job, but nods as he likes the idea of going to the cabin in New Hampshire. He was there only once, a few months before; they had not stayed overnight as his mother insisted on staying at a hotel. Although it was late May, it wasn't warm enough for her in the cabin.

Sam is excited about having time with his father—he is fun to be with; they both laugh together. His father laughs most of the time, while his mother is usually serious. His father is fast-moving and his mother is careful. Though he loves his mother, he prefers his father's presence.

On the drive that Friday evening to the north country, Sam falls asleep early on. His father allows him to lie across the back seat without his seatbelt on. Then he places a blanket over his son, and Sam feels very snug and secure. His father listens to classic jazz music on the way up. Sam likes the jazz music too, he

identifies with it in some way, the back-and-forth quality of it; it is like him, back and forth between his mother and father.

The traffic is heavy, and Sam's father, hearing Sam's little breaths in the back seat, wonders if he should have waited until tomorrow to drive up, but he has had a yearning to be in his cabin; he is the most content there. Driving up now gives him more time alone with Sam, he rationalizes. Then he promises himself that they will drive back very early on Sunday morning so that Sam can see Naomi.

Jack parks the car in front of the cabin and buttons up his jacket; the temperature has dropped. Then he gets out of the car and opens the back door. He lifts up Sam and carries him over his shoulder.

Opening the door with his key, he sees that a light is on and assumes he forgot to switch it off during his last visit. His eyes scan the living area and in the far corner there is one of his friends, half-dressed, fast asleep, a whisky bottle at his feet. Jack's heart sinks at the sight. Soon, though, he is diverted; Sam has awakened and is fully eyeing Jack's friend, his eyes widening with anger. Within seconds, Sam is crying for his mother.

42

*B*eneath her father's desk, Raine, four years old, lies on her side, her hands clasped; she is waiting. He has not come into his office yet. She and her mother and brother and young sister finished dinner a little while ago.

She plans to show him the picture she found in a book on cats—she likes pictures of animals and likes presenting them to her father. Whenever she shows him a picture, he will smile, and ask in a soft voice, "Now where did you get that, Raine?"

She will look up at him with wonder in her eyes and tell him that she found it in the library or in a magazine that belongs to her mother. He'll lightly touch her head and say, "Very nice, Raine, you are always searching, aren't you?"

And she'll nod enthusiastically, not certain what "searching" means.

This evening underneath his desk, she is lying on a book that she has found in the preschool library this day. She has asked the teacher if she may take it home to show her father. At first her

teacher was doubtful, but then told Raine she could bring it home but she needs to return it tomorrow. Recalling this now, she feels the book firmly beneath her.

After a while, Raine hears footsteps and takes a deep breath—she knows her mother will not come to look for her in here. She isn't aware that Raine hides beneath the desk as much as she does, especially after dinner. Raine thinks her mother will believe she is in bed where she left her twenty minutes before. Her father did not come home for dinner and Raine knows when this happens, her mother will sometimes come into his office and wait for him.

From beneath the desk she recognizes her mother's legs; she is walking into the room, but she doesn't go to the couch and sit down, and neither does she go to the shelf where her father's sculpted figures are and pick up one and stare at it for a long time. Raine senses something different in her mother's movements, and her heart begins to beat rapidly; she imagines she can hear it and thinks her mother may do so as well. Peering up, she briefly catches the expression on her mother's face and is frightened— her mother's lips are turned downward, her eyes are swollen, and her face is very red.

Her mother goes over to the cabinet beneath the shelf where the sculpted figures are. She crouches down, then kneels and flings open the door. She removes a pile of papers from within and begins going through them, tossing one after the other onto the floor. Soon the papers are strewn over the rug, and Raine thinks of running out from under the desk; she is becoming more

and more frightened because of the change in her mother—she cannot tolerate the intensity of it. She needs to escape, but knows her mother will see her run by.

Her mother seems to have found what she has been looking for; she stands up, goes over to the desk, and Raine hears her switching on the lamp. Raine guesses she is reading the paper under the light of the lamp; she has seen her do so before. Her mother always needs more light to see.

Raine hears the front door opening; her father is home. But she doesn't think her mother knows. His footsteps come closer but her mother, she believes, is still reading the paper. Then she hears her father's voice, sounding harsh, "Dania, what on earth . . ."

Then Raine spots her mother facing her father, her mother yelling out to him, shoving the paper she's been holding in his face. "You are a criminal—a thief! You will destroy us, our children."

"But Dania," he speaks evenly. Raine sees him put his hands in his pants pockets. "You have always known this—your intuition. How could you not have known or even guessed? Don't pretend you are innocent."

They begin to talk in loud, hateful voices, yelling, using harsh sounding words Raine has never heard before. Her mother and father are standing close to each other, nearly touching.

Beneath the desk, Raine begins to shake; her father puts his hand over his stomach and cries out in pain. He bends over, still holding on to his stomach. Her mother steps away, remains still; Raine watches him, quivering, eyes him falling to the floor. Her mother turns away, hastily leaves the room.

Soon she hears the sound of an ambulance, and sees men come through the door and take her father out on a stretcher. Raine has nowhere to go—exhausted from her fright, she sleeps.

Hours later she awakens to the sound of her mother calling out her name; dazed, she begins to crawl out from beneath the desk. She stops. Frozen in place, she feels separate from her body, her mind racing.

She hears her mother's approaching footsteps. Now she is standing in the office doorway. Her hair is uncombed, her eyes more swollen, her face now pale, her expression haggard. She cries out in anguish, "Raine, how long have you been here?" As she picks up her daughter, Raine collapses in her arms.

Lia's Journal

The Present

43

June 21: Three years have passed since we met Raine and Ned in the breakfast room of the Edinburgh hotel. I remember the morning very well, the strong sun, followed by a brief rainstorm, and then sunlight again, lasting into the evening. How exhausted Sam and I were from the overnight flight, and how, despite our weariness, we crossed paths with Ned and Raine, never imagining our friendship would have continued to this day.

To acknowledge this anniversary, they will come to our home this midsummer evening. In my thirty-eighth week of pregnancy, I do not move about very much; the baby may come at any time. Sam will prepare dinner. He tends to cater to me now, but I realize more and more, he always has.

We have not seen Raine and Ned since late March—a two-hour dinner in a Cambridge restaurant we all like. At the time we spoke about the horribly cold winter we'd just experienced. Ned said the solitude of those days had helped him come to a decision about his future, that he didn't want to toy around with local politics anymore; it wasn't really his personality. Instead, he had submitted an application to be the Paris correspondent

for the newspaper—the current one was retiring. He added that over the winter, he realized he preferred writing about international matters, international politics—it was much less personal to him.

A few weeks ago he called to report that he and Raine would be moving to Paris in late June. And so, this evening, not only will we be celebrating our third-year reunion, we will say goodbye to Ned and Raine. Yes, we may see them from time to time, whenever we visit Paris, or when they return to New England for the holidays. But I do not know how often we will have a chance to travel with a young child over the next few years. I imagine their visits to Massachusetts will be only for a week, and will be filled with family activities.

Over dinner three months ago, Raine told me her way of coping with the endless winter had been to try painting with watercolors. Her intention was not to become a watercolorist, but to discover something about herself, something deep within, something she needed to resolve but had not been able to discern. I asked her if painting had helped in any way. She looked over at me and said that she thought so, and that the mind works in interesting ways, that certain memories are fleeting at best, and that is fine, beautiful. Why should everything in our lives be spelled out? She added that her attempts at painting have improved her drawing and now she calls herself an illustrator—a title that suits her much better than commercial artist.

Raine asked about my pregnancy; there were none of those moments of dissociation on her part. She seemed to have found herself—I didn't ask if in addition to her painting with watercolors, she'd been to therapy—whatever it was that caused her to become more reconciled was her business, not mine. She seemed more settled, more relaxed, less restive.

"May I touch?" she asked, reaching out with her small hands to pat my stomach.

I nodded and smiled. It was unlike her to ask that, and unlike me to so easily have acquiesced; but she has changed these past three years and so have I.

Because of the world we live in, we have matured in a more cautious, more factual way than our parents, who seem to have had more freedom to question and imagine. I do not know if we are better off for it or not.

* * *

The front doorbell rings. Sam comes into the living room and hurries to open the door; he is looking forward to showing our new home to Raine and Ned. I start to raise myself from the sofa to greet Raine and Ned. Sam puts up his hand and says, "They will come to you, Lia."

In the doorway, they each hug Sam. Their voices are filled with excitement—it must be because of their upcoming move to Paris. And Sam is thrilled about our soon-to-be-born child.

We do not know whether it will be a boy or girl, have refused to ask—we want to be surprised. There are so few unknowns in this day and age. I hear Raine's throaty laugh and Ned's even-handed and mildly shy, "Great to see you, Sam."

Then they walk down a step into the living area. As she always has, Raine moves like a dancer; she comes toward me. Her eyes are bright with anticipation. I start to get up.

"No, Lia—do not budge," she says in her insistent voice, a touch of the old Raine. But then when she embraces me, she is warmer than she ever has been—she is more than what she was three years ago.

Although we have not often met with Ned and Raine in the past three years—eight times at the most—we share a bond, a result of that incident in Antibes. It was an incident that perhaps wasn't very significant—it worked out well in that no one was physically harmed—but it affected each of us in some way. We all needed to move forward in our lives, and for one reason or another we had not been able to do so.

There had been a series of break-ins at the hotels in the old section of Antibes that summer, and Raine and the woman she encountered in the restroom were in the wrong place at the wrong time. They were locked in a room by the woman who was working as a hotel clerk on the overnight shift. The clerk wanted her accomplices to go into the storage area behind the front desk and steal from the patrons who left their valuables there for safe-keeping; Raine and the other woman had been in the way. By

the time Sam and I arrived, the hotel clerk and her accomplices had left.

* * *

No longer does there appear to be a lingering connection between Sam and Raine, one that I detected during our travels and one that I believe Ned did as well. He never said it to me directly, but one evening about two years ago, Sam and Raine were embroiled in a conversation about Picasso. How could his grandmother have appreciated him, wasn't he indifferent and cold to women? Raine had pressed Sam for an answer. And I had studied Ned's expression; he seemed pained. He became aware of me staring at him; looking over, he gave me a bemused smile.

I did not forget that moment, but refrained from saying anything to Sam. For I still felt relatively guilty about my wanting to have an affair with Ron. It was not until last October that it occurred to me for the first time that my desire to have an affair with Ron may have had more to do with my need to leave teaching. When I told the principal I was leaving early that day to see a doctor, that I believed I might be pregnant, she asked, if I were to have a baby, would I return to teaching. I knew she assumed I would, as I had thought so too. I told her I would not come back—it had just come to me. It struck me that maybe it was why I had been attracted to Ron—I had been searching for an escape.

Later that October day, the doctor confirmed my pregnancy. I was looking forward to telling Sam. I went to the coffee shop where we were to meet; he was sitting with Ned. Once Ned left, I asked Sam point blank if he had known Raine before Edinburgh. Answering in an uncharacteristic dreamy way, he said he may have met her in Florida just after his grandmother had passed; he may have been staying at the same hotel as her. But it was all hazy to him and he was not even certain it was Raine. Raine, or the woman who was not Raine, had told him about something horrible she had seen as a child—maybe someone dying or causing someone to die. They had discussed it while drinking at the hotel bar. He added that he was certain that was what she had said even though he'd had too much to drink—he just wasn't convinced it was Raine.

I replied that if it was Raine, it would be an unbelievable coincidence. He shrugged, and I understood he was not able to resolve whether or not it had been our friend.

I didn't ask Sam if the meeting with this supposed woman who might have been Raine had turned sexual; I thought, sexual or not, does it matter? Wasn't what she had revealed to him intimate, if true?

On this third anniversary of our meeting that midsummer day—a midsummer day that, in a sense, has lasted three years— Sam and Raine appear friendly yet indifferent to each other. The uneasy connection between them has apparently dissolved.

We speak of our plans. We promise to contact Ned and Raine once the baby is born. We imagine how Ned and Raine's

life in Paris will be, a fulfilling experience for both. They appear confident, elated; I wonder if they will ever return.

When we part, we think solely of the future; like most, we have no awareness of the embedded memories of the past, other than the feelings and impressions they evoke, that hover over us—yet we keep them at an appropriate distance. For I have no doubt each of us intends to live fully in the present. We have awakened.

"I would hear you at night, Phoebe's begging for you to stop, but Autumn never did. Autumn lay there as you destroyed her because she knew that you would do the same thing to Phoebe if she didn't. Phoebe was an infant, Jonathan! She was a baby!"

I had never heard her speak with such emotion before. She was screaming at him, her eyes pouring with tears.

"Phoebe was the one who had to find Autumn. I had to hide the suicide note from her. I didn't want her to know what you did to her sister. Then you started doing the same thing to Phoebe. You threatened to kill me if I told anyone about what you were doing to her. I didn't want to lose my own life, so I didn't say anything, or did you forget that?

They were your fucking children, and you did unspeakable things to them. You are the reason my babies are dead. You are the reason my oldest child is six feet in the ground and my youngest had to fake her own death just to stay safe. I wake up every morning, and I want you dead. I want nothing more than to take back everything I did and apologize to Autumn and Phoebe, but I can't, so I can do this.

If the judge and the jury take anything away from this trial, let it be this. This man sitting in front of you ruined everything that this family loved. Everything he touches is destroyed."

Jonathan looked at her like he had no idea what to say. She glared back at him, anger filling her eyes as she stared at her husband.

"No further questions, your honor," Jonathan's lawyer says finally before walking back to her seat.

I had never seen Reno stand up so quickly in his life. He waltzed over to the stand as Genevieve watched his every move.

"I would like to ask some questions, your honor," he says.

When the judge nods, he turns towards Genevieve. Alexander reaches under the table and grabs my hand, squeezing all feeling out of it. Both of us knew what this meant for the case.

Mrs. Conners had just testified against her husband. She knew what he had done throughout the years, and she was willing to say everything he did. After telling us for years she would never do anything that would betray his trust, she turned against him and told the jury exactly what had happened.

"Mrs. Conners, when was the first time Jonathan Conners hit you?"

"It was ten days after we had gotten married. I didn't have dinner ready when he got home. He got upset, and I thought it was ridiculous, but he didn't think it was as funny as I thought it was. While I was telling him he was overreacting, he reached back and smacked me. I couldn't believe that he had done it, but he just told me he wouldn't hold back next time," she answers.

Reno looks towards us out of his eye and sees Alexander clutching my hand. He turned back towards Mrs. Conners and proceeded to question her.

"When was the first time you knew he had raped Autumn?" Reno asks.

She freezes for a moment. I could tell she didn't want to answer the question. She looked like she wanted to be anywhere but where she was, but she straightened and spoke.

"She was four years old. The sounds of her father woke me up, and he walked into the room a couple of minutes later. I pretended to be asleep, not wanting him to know I had heard him. I left when I knew he was asleep and went to check on Autumn.

I will never be able to forget how Autumn looked on that bed. That poor little girl was curled into the corner of her bed, trying to dry her tears with the corner of her t-shirt. I wanted to say something. I wanted to do anything to make her feel better, but

there was nothing I would be able to do. I left the door propped open when I went to check on Phoebe. She was sound asleep.

I held Autumn that night, crying as I tried to understand why he would have done what he did. Phoebe didn't even cry. She didn't wake up. She just laid there in my arms."

"Mrs. Conners, did Autumn ever tell you what was happening?" Reno asks.

She shakes her head. "She never told anyone. I heard her and Jonathan arguing a few times, and she would say something along the lines, but he would tell her that if she didn't stop, he would hurt her even more. She would keep going. It was as if she had no concern for her well-being. The only time I knew what she was happening was in her suicide note. She said everything that had happened to her since she was four years old. It was addressed to Phoebe. She told Phoebe that she had to be careful around Jonathan and promised she wouldn't miss her too much. I hid the note from Phoebe. I didn't want her to know what had happened to her sister, so I took it away. She had already been through so much since finding Autumn. I didn't think she needed any more pain."

Reno kept asking Genevieve questions, and she answered every single one. Tears were spilling down Phoebe's face as her mother continued to speak.

Alexander, Carson and I shared a look. This was it. We had won. After both Phoebe and her mother testified, there was no way anyone could say nothing had happened to the girls.

"No further questions, your honor," Reno says, moving and sitting next to us.

The judge banged her gavel, dismissing us for a thirty minute recess. Phoebe breaks free from the table, racing towards her mother. Genevieve cowers back for a moment, as if expecting Phoebe to scream at her. When Phoebe gets to her, she wraps

her arms around her mother, breaking down into her shoulder. Geneieve doesn't try and hold herself back anymore. She sobs. She holds her child to her chest as if she would disappear when she let her go.

"I thought I had lost you," I hear her whisper.

This only makes Phoebe sob harder. Geneieve takes a second, picking up her head to smile down at me, before directing her attention back to Phoebe. I turn away, a smile covering my face.

"Did you know this was going to happen?" I ask Reno.

A soft smile covers his features as he turns towards me.

"I had a good idea."

We wait for Phoebe and her mother outside of the courtroom. When we watch others begin to file in, we do as well. Phoebe is already sitting at the table, a smile covering her tear stained cheeks.

None of us were truly paying attention to the other witnesses that were called. We knew none of them really mattered. It was all a formality. We had won. Deep down I knew it. We all know it. We al knew there was absolutely nothing anyone could say that would change the juries mind about the information that was delivered.

When we were finally dismissed Phoebe said goodbye to her mother, promising to meet her sometime so they could talk. We kept our heads down as reporters screamed out questions about the information delivered today. None of us said a thing until we pulled into the driveway of the Conners house.

The minute we step out of the car, every single one of us is screaming. Phoebe threw herself in my arms, pressing a kiss to my lips.

"Holy shit," Alexander yells. "Holy fucking shit."

"I can't believe it," Phoebe whispers. "My entire life she never said a single bad thing about my father. Would never even think about saying anything against him. Now she told the entire world.

She told every single person on that jury she knew exactly what was happening the entire time."

She turns towards Carson.

"Carson, I can't even begin to thank you for everything you have done for us. I know how difficult coming forward was. Autumn would be so proud of you."

Carson smiles, wrapping her arms around Phoebe.

"I'm so happy you're okay," she whispers. "I think that would make Autumn the proudest."

Phoebe breaks away, turning back towards Alexander and I.

Be honest with me. How good are our chances of winning this thing?"

Alexander wraps his arms around her. 'We did it Phoebe. We have finally done it."

Phoebe laughs, freeing her hands and pulling Carson and I into their hug.

"Thank you both for everything. None of this would have happened without you."

We don't have to speak for her to know exactly what we were both thinking. We would go to the ends of the earth for her. There is nothing she could do that would ever tear us away from her. After everything we had been through in the past six years, the four of us were never letting each other go again.

After

Jonathan continued calling as many people to the stand as possible and kept asking many of the same questions. He even went as far as to call people from Ireland, where he is Genevieve, supposedly went to spread Autumn's ashes. Finally, the judge demanded he call one credible witness, or he would be forced to close the trial and have no more witnesses called up. Jonathan knew he was running out of time. He had to call one credible witness to try and get people to be on his side.

As far as Reno had heard, the jury was leaning toward our side. There was no doubt that Jonathan had heard the same thing. He was trying anything and everything to try and get anyone on his side. Finally, Jonathan knew nothing he could do, so he called in one last witness and was determined to make it his best.

Phoebe, Alexander and I walked in that day, knowing it would be one of the last days we would be in this courtroom. After this, the jury would go in and deliberate. After this, there would be nothing else we could do to prove to everyone in this courtroom the truth about what happened to the Conners.

The four of us had come to an agreement. After the case. After the jury was finished deliberating and we got a final decision, we would move on. We wouldn't talk about the case to news outlets. We wouldn't go out of our way to discuss it with anyone. We had six years of constant reminders. Six years of everyone asking us questions. Six years of not letting a single detail go.

We all needed a fresh start. We needed time where we could be normal people again. We were all determind to get that after this case. The constant reminders would be gone. We would let ourselves breath again.

When we finally sat down, all of us were anxious for the case to be over. Desperate for the worst years of our lives to finally be over. We sat in the same formatted line we had throughout the entire case. None of us said anything as we waited for the judge to enter. We remained silent as the judge walked in and we stood up. We remained silent as we sat back down and waited for Joanthan's lawyer to call their final witness.

"I would like to call Dr. Micheal Driver to the stand," we hear.

We all turned and saw Dr. Micheal Driver walk up to the stand. I would recognize him anywhere. He was the same one who was said to have done the autopsy of Phoebe. He was the one who told us all he noticed no signs of sexual assault ever. The one who had promised me nothing was ary and she had just lied to me to get my attention. From the way Phoebe is gripping my hand, I can tell she recognizes him as well.

"Dr. Micheal Driver, you were the one who composed Phoebe Conners's exam. Is that correct?"

"Yes, that is correct," Driver answers.

"And at the time when you were composing the autopsy, you noticed nothing out of the ordinary?" Jonathan asks again.

"I noticed nothing odd in my exam."

"Now, there was speculation my client paid you not to say anything about a possible domestic situation. Was that the truth?"

"No, I was not paid off by Jonathan Conners. I simply did not notice anything off during my examination," Driver responds.

Jonathan looks at us from the corner of his eye with a smile.

"No further questions, your honor.".

Reno looks towards me, and when I nod, he looks towards the judge. "I would like to ask a few questions, your honor."

When the judge nods, he rises from his seat, not before grabbing my hand and squeezing it.

"Dr. Driver, you claim that Jonathan Conners did not pay you off, and yet, just two days after the exam was conducted, you received 30,000 dollars in your account from an unknown source. You claimed this was just an advance on your trust fund, but your trust fund had been available to you for ten years. Why would you lie about the money in your account?" Reno asks him.

Driver doesn't even flinch as he stares at Reno.

"It was an advance for my sister's trust fund. She kept trying to access it, so I took it upon myself to move the money to my account so even if she were to get into it, there would be no money in the account," he answers.

"It's funny you mention that as well. We contacted your sister and her bankers, and her money is still in the trust fund. So since you have been lying under oath already, I would suggest you tell us the truth about where the money came from," Reno tells him,

That wipes the smirk right off of Driver's face. He looked around as if he was trying to find someone to help him. Jonathan wasn't even looking at him. I could tell Driver was trying desperately to try and get Jonathan to say anything that would help him in this case, but Conners was saying nothing.

"I received the money from Conners, but not as a bribe. He gave me the money as a thank you for conducting his daughter's exam. That was all," Driver choked out.

Reno walks over towards him. He wasn't pacing like he usually does. He was staring right at him, looking him right in the eyes. It was like he was peering into the soul.

"Dr. Driver, do you believe that Jonathan would have paid a different technician the same? That seems the most logical out of

everything you have told me. We have looked into the payroll and found that a mass amount of Mr. Conners's donation goes into paying your salary. So maybe, this was not just a thank you for $30,000. Maybe Jonathan Conners knew how much his donations did for that entire office and knew that if he threatened to take away that donation. Maybe he offered an extra 30,000 if you just kept it a secret. Now you have already committed perjury in this trial, so I would again suggest speaking the truth unless you want more than just a small fine," Reno tells him.

Driver looks back and forth between Reno and Jonathan with a look of panic. Phoebe's han tightened on my own.

"Dr. Driver, I would suggest saying something soon because, as far as I am concerned, your silence speaks more than your words could ever," Reno growls.

"Fine!" Driver screams out. "He paid me off. He didn't want anyone to know what he had done to his daughter. He did the same thing with his other one. I didn't want to take it, but my boss said I had to because of how much Jonathan Conners donated. You have to believe me that I never wanted any of this. I only got the extra 30,000 because of my initial concerns. I saw the signs of sexual assault. There was no mistaking that they were there. I needed to keep my job. That is the only reason I did this. Please, I needed to be able to live. I needed this for my family. That's the only reason I would have ever taken the money I swear!"

That was it. This was the final piece of the puzzle we needed, and it slipped out from him like it was nothing.

"No further questions, your honor," Reno says.

We all turned back to look at Jonathan, and he looked more upset than he had been when Genevieve spilled everything.

"The defense rests its case," his lawyer mutters.

After the jury deliberated, the judge outlined everything that would happen, but I was only half paying attention. This trial was almost over. We had one more day, and then this would be over.

"The court is dismissed," the judge says.

That was it. We were free to go. The next time we had to come in was when the jury had reached its decision.

Phoebe, Alexander, Reno, Carson and I drove back to the house to celebrate. My mom and the rest of my family were there when we returned. My mother wrapped Phoebe in a hug, apologizing for the years of hurt she had caused for her.

My family attached themselves to us for the rest of the night. Cindy was ecstatic Phoebe was back, taking the oppurtunity to catch Phoebe up on every single thing that had been happening in her life. The second I could, I broke away from my family. I moved to the kitchen, the quiet allowing me to time to breathe.

The trial was over. There was nothing else I could do now. I had wanted this for so long. Had wanted to finally brin the justice Phoebe deserved, but now that we were here, I was terrified. I didn't know what was going to happen after this. For so long, my life had been Phoebe. It had been this case. For six years, I had nothing else in my life.

I couldn't go back to normal after this. I wasn't even sure what normal was. Everything after this case was unprecedented. I never planned on what happened after. For so long my life had been figuring out what was going to happen during the trial. It was preparing for the trial. It never even crossed my mind to figure out what would happen after the trial.

I hear a loud cheer come from the other room. I crane my neck to look around the wall. There was Phoebel, surrounded by my entire family, smiling and laughing. Phoebe Conners and the Garcia's in the same room without tearing each other apart. Something I never once thought would happen.

I turn back, my head coming to rest in my hands. Six years ago I would never have thought we would be here. I never would have thought I could live a happy life again. I had made it six years. Six years, 72 months, 313 weeks, 2191 days, 3,153,600 minutes and 189,216,000 seconds.

I had made it this far. I could make it after this trial. I could figure out what I was going to do with my life. If I was able to figure all of this out in six years, I had nothing to worry about for the rest of my life.

I walked back into the living room, attaching myself to Phoebe's hip. Drinks were passed around and a toast was made. A toast to all of us. A toast to what we had accomplished in the years we spent together. A toast to the testament of time.

Everyone stayed in a guest bedroom that night. My family didn't want to leave me alone. After midnight, it was just Phoebe and I sitting on the chairs by the kitchen island.

"How are you feeling?" Phoebe asks.

I look over towards her, studying her face. She had more weight to her. Her cheeks were rounder, rosier. She had formed smile lines, but you could still see those dimples. Pieces that usually framed her face was in front of her eyes, but you could still see the familiar blue. The deep ocean blue that you felt you could get lost in. They didn't have a troubled look to them anymore. When you looked into her eyes, you didn't immediately assume something was wrong. There was a happiness to them. A sense of comfort. Something that hadn't been there before.

"I wanted this case to be over for so long. I wanted him to get what was coming for him for the longest time, but now that it's almost over, I don't know what to think. I spent so much of my life dedicated to this, I'm not sure what comes after this," I answered.

She smiles, leaning over and resting her head on my shoulder.

"I wanted revenge for so long. I wanted him to get what was coming to him but now that's it's finally here, I realize I don't know how to live a normal life. I don't know what it's like to have people in my life that don't leave. Nothing in my life has ever been steady and now there is a chance that could happen. Wben it does, I want it to be with you."

I look down, her head resting on my shoulder.

"You were the only constant in my life. I want it to stay that way," she whispers.

I guide her face up to mine, pressing a soft kiss to her lips.

"I love you Phoebe Conners. We'll get through all of this together. You and me for the rest of our lives."

She kisses me again, her lips moving slowly against my own.

"Forever," she whispers when she separates. "I never knew the meaning of that word before you came along Sydney Garcia."

After

It took the jury two weeks to finish their deliberation. Alexander, Carson, Phoebe and I waited at the Conners house the entire time. We filled our days with meaningless activities. None of us mentioned the trial. We would spend our days together and at night, it would be me and Phoebe in her room and Carson and Alexander in their own guest bedrooms.

Every ring of the phone sent us running. Every knock on the door set our heartbeats racing. Reno would call us everyday and reassure us a verdict was coming soon. My family would reach out everyday asking the same question. Everyday I would have to give them the same answer. We hadn't heard anything.

It was 8 am when we got the call. The jury had reached a decision. We were to be at the courthouse in an hour. After the call, Phoebe was no where to be found. It was 8:40 before we found her. She was sitting on the bathroom floor, staring at the claw foot bathtub adjacent to Autumn's room.

"Phoebe, come on we have to go," I called.

She didn't move.

"Phoebs, we have to go, can you hear me?"

She didn't answer.

I moved to sit next to her. Her body didn't react as I sat down next to her.

"This is where I found Autumn," she whispers, her voice sounding hoarse. "In twenty minutes this will all be over. Everything Autumn fought for will be over. After this, she will just

423

be the Conners daughter who succeeded in killing herself. After this, the both of us will be nothing."

I grab her face in my hands, turning her head to face mine.

"Autumn will never be nothing. You will never be nothing. You two fought for this your entire lives. In twenty minutes everything the both of you have worked your entire life for will be over. She will have succeeded. You will have succeeded. That was all Autumn wanted from you. She would be happy. She would be so happy that after all of this, you will finally be able to get the life you both deserved."

Tears fill her eyes as she stares into my eyes.

"I don't want her to disappear Sydney," she whispers.

"When you love someone as much as you love her, they disappear. You could want them to leave your mind. To never remember them again, but they don't go away. She loved you Phoebe. You loved her. That is something you will always remember of her."

She turns her head back towards the bathtub. I watch as she takes a deep breath before pushing herself up off of the ground.

"I'm ready," she whispers.

WE PASSED THE FLASHING lights of cameras one last time before walking into the courthouse. We were the last ones to arrive. We took our seats next to Reno. My hand immediately searches for Phoebe's, finding it and gripping it tight.

I looked over towards where Jonathan sat. He was looking the worst I had seen him look in six years. For the first time, he actually looked like a man who had spent time in prison.

We waited with bated breaths as the judge begins to go over everything Jonathan was charged with. Phoebe's hand begins to

shake in mine. I hold on tight as if her hand was the only thing grounding me.

We watched as the judge reached and grabbed the envelope with the jury's decision. Time seemed to pass by as slowly as possible as she opened it. My breath caught in my throat as she took out the paper and began reading.

"We, the jury, in a unanimous decision, found the defendant guilty."

My heart stops. We had won. He was guilty. I turn towards Alexander, tears filling my eyes. Carson is staring with a look or surprise in her eyes as she watches the judge place the paper on the stand.

I feel Phoebe's hand fall out of my own. I turn to look towards her, expecting to find her with a smile and tears. We had done it. She had to be happy she had done it.

A loud bang resounded throughout the entire courtroom. I screamed from the spectators all around us. In the panic, my eyes dart over towards where Phoebe is standing, her hand wrapped around a pistol in her grip. Jonathan Conners is down on the floor, blood seeping into the carpet all around him. One well-placed shot to the left side of his chest.

Her hands aren't shaking as she stares down at him. She lowers the gun, stalking over to where he was laying. She stands over him, her eyes filled with pure hatred.

"I did it Autumn. It's all over."

Authors Note

When I first began writing this book, I was angry. I was angry at the Don't Say Gay bill in Florida. I was angry at the overturning of Roe v Wade. I was angry at the world. Since writing, I have gotten more reasons to be angry. The odds are stacked against queer people in the United States. I can't say they never have been but even more now.

I wrote this story to tell the side of a story that does not get told. I wrote this to talk about the side that we don't hear but exists. Queer teen suicide rates are higher than they ever have been because of policies that are being put in place. Because of legislation like Florida's Don't Say Gay Bill or Ohio's House Bill 616. Legislators are trying to erase queer and people of color from history.

In America you see the Westboro Baptist Church show up to a funeral of a military official or a child and scream that the person died because God is trying to punish everyone for enabling homosexuals. Grown adults will go onto the social media pages of same sex couples with their children and call these parents child groomers. Adults will go and shoot or bomb a drag bar stating they are protecting the children. We allow people like this to walk around and spew their hate because they have the right to assembly and they have freedom of speech.

As I was going through the process of publishing, the genocide in Palestine started. Every day I open my phone continually surprised by the harm human beings can caused unto each other. I still am in shock but as a human living in this world, we have a duty to speak out about injustices happening to our fellow humans. Please, continue to post about Palestine. Continue to donate to whoever you can to help get their family members out of a dangerous situation. No child deserves to go to bed not knowing if they would survive the night. No mother deserves to have to

choose which child she is going to feed. Children should be able to live and that is not a radical statement.

Nothing will ever get done if we don't stand up and say something. For both the ongoing genocide in Gaza and the state of queer people in this country, we have the direct power to affect changes. This is a call to action. If you are not registered to vote yet, then you HAVE to register now. You have the ability to command change and if we don't vote then we don't have a voice.

If voting is not a power you have, call your representatives. Never let them forget they were voted to represent their contituents interests. They were elected to be teh voice of the people in their district. Remind them what voice they are meant to be uplifting. Never stop fighting against the injustices in this world. Continue to use your voice to stand up for what you know is right.

Free Palestine is not a radical statement. My body my choice is not a radical statement. Queer people deserve to live in peace is not a radical statement. Stop funding a genocide isn't a radical statement.

Things seem dismal right now and I completly understand the world can feel impossible. It feels as though we are fighting a losing battle sometimes, but this is where I tell you once again you have the power to evoke change. Speak up and speak out against injustices.

Acknowledgments

I truly can't even believe that I am writing this right now but here I am. There are so many people that I have to thank but I first have to thank my parents who let me shut myself in my room for hours on end while frustratingly attempting to fix plot holes. To my best friends who allowed me to talk for hours and hours upon end about the book and the struggles that were ongoing. You guys are the real troopers.

I would be remiss to not thank my grandma and papa before most. By the time this book is released, you will have been gone for 7 years and that's still insane to me. To my grandma, you taught me to love reading and all things theatre. You built me up to be the person I am today. I am proud everyday to look so much like you and will carry on your hardworking legacy for as long as I am alive. To my papa, you taught me to be the strong woman that I am today, You taught me the value of heard work and how hard work pays off everyday. I miss the both of you more than life itself but I know wherever you are you are proud of me.

To my therapist who let me vent and allowed me to create this outlet that has become this book I thank you for the hours you have dedicated to helping me over the past four years. You're a real one queen. To my teachers that allowed me to sit in class with my laptop open reading through all of my various edits, thank you for not mentioning the fact I wasn't paying attention at all to your class.

A special thanks to my 8th grade social studies teacher who I am still in contact with today. Ms. Sherwood you are singlehandely the reason I kept writing after my shitty as first novel that I gave up on halfway through the year and looked over my shoulder in Wake Forest Coffee Company that one day to find me researching the death penalty in Indiana (iykyk). Thanks for being the one teacher

THE PAIN OF AFTER

I am still in contact with and answering my emails. I'll send you a signed copy as soon as I can.

To my Aunt, Jeanette Grey, who fielded all of my questions and listened as I complained about how frustrating the publishing process is as if you didn't know. You knew and you let me vent. Thank your for everything and if you all haven't gone and read any of her books go and read them because she is incredible.

For my boss who let me sit at the only table in the restaurant and write until we got a customer and I had to make their salads. You're the best girl and there's a reason I never want to leave this job. You also listened to me complain and you are always ready to hear the daily gossip while sharing your own. Thanks queen.

Now to the more obscure thanks. Thank you to Taylor Swift whose songs who have been raising me since I was a young child. Thank you to Boygenius whose concert I went to in June of 2023 but also whose album pretty much scripted this album. Also thanks to Phoebe Bridgers for being my first wlw crush. Thanks to Noah Kahan who wrote an album that literally sounded like going back to my hometown. To the people on instagram that post photos of cows and bears on instagram who distracted me more than anything else did on this album. Thanks to the person who created Taylor Swift 2048 for also being the biggest distraction.

Thanks to the people who have been following me on Instagram and Tik Tok since the beginning. Y'all are the real ones here and you are the ORIGINAL EM fans. If you aren't following me on social media you should because in my own personal opinion, i'm really funny. Find me at em__jones21 on Instagram and em_jones21 on Tik Tok.

Thanks to everyone for reading this and look out for some more information upcoming a new series??

About the Author

The Pain of After is Em Jones's first novel. When not writing she can be found fantasizing about the fall, drinking an unhealthy amount of coffee, playing with her dogs or attending too many concerts for her bank account to handle.

After

I slept in Phoebe's arms that night. Her weight was familiar. A distant memory I once remembered. The rise and fall of her chest lulling me to sleep. I slept soundly for the first time in years. No nightmares. No waking up in the middle of the night. Nothing. Just Phoebe and I.

I didn't want to get out of bed that next morning. I knew the minute we did, reality would kick in. We would still be in the middle of a trial and she would still have to face her father. I would have to face my father. Face the fact he was partially to blame for this. Face the fact that the man I thought I had known my entire life was gone.

My father once told me he hated Phoebe Conners because she never learned from her mistakes. He said she would come in with the same charge as the previous time and act the same way she had been each time before. After his testimony, I refused to believe that was the truth. I believe everytime she would walk into that station he realized he would have to do the same thing he had done everytime before. Phoebe Conners reminded him of everything he had ever done wrong.

I said for the longest time that there was no one to blame but Phoebe's father but it was everyone's fault. It was Alexander and I's fault for not saying anything. It was my dads fault for taking the bribes. It was the departments fault for doing everything my father told them.

It wasn't one singular person's fault anymore. It was everyone. It was this entire godforsaken town and their hatred against Phoebe. It was the entire world's fault for not being the place she needed to be able to talk about what happened to her. It was this entire universe's fault for failing the one woman I loved.

WHAT ARE YOU GOING to do about your father" Phoebe asks me, her hand finding mine in the empty courtroom. I shook my head.

"I don't know. A part of me always knews this is what happened. I didn't want to admit it to myself that he was at fault."

She presses a kiss to my knuckles, her lips comforting against my shaking hands.

"It's not his fault Sydney. He had everyone in this town wrapped around his fingers. He was just doing what he thought was best."

"It's still his fault. He knew it was wrong. He knew he shouldn't have done it and yet he did. It doesn't make it any less excusable."

She looks down at me, a sad smile playing at her features.

"Sydney, you have a father who loves you. Your father did everything he could for you. He did what he thought was going to be the best for the town and your family. Don't lose your relationship with your father because of this. I'm here. It ended up okay. I understand that you are mad at him, but don't let this all go because you are upset at something that happened in the past," she tells me.

She was right. I knew she was. I didn't want to admit it. Didn't want to admit that he didn't have bad intentions doing it. He truly thought he was doing what was best for the family. She knew what it was like to have the relationship she did with a father. She knew

what it was like to have one who couldn't care less for you. My father loved me.

The feeling of Phoebe's hand gripping mine ripped me out of my thoughts. I turn my head to look where she was. There was her father, being escorted into the courtroom. I squeezed her hand, trying to reassure her that everything was going to be okay.

"I want him dead," I hear her whispers. "I want the fucker to die."

Alexander sits on the other side of her, wrapping an arm around her shoulder to try and distract her from her father.

"That's why we are here," he whispers. "We are here to make sure he gets what he deserves."

"Jail isn't enough for him," she mutters. "The only thing that would make the two of us even is if I get to watch the light drain from his eyes."

Alexander an I share a look over Phoebe's head. We had both thought the same thing before. Had both uttered the words out loud, but coming from Phoebe, it wasn't just a thought. It was a promise. A promise that she would get what she was owed.

The judge bangs her gavel, allowing Jonathan's lawyer to call her first witness.

"I would like to call Genevieve Conners to the stand," she says.

My heart stops beating in my chest—Phoebe's mother. Phoebe's mother refused to testify for anyone, and yet here she was, testifying for him. I look over towards Phoebe. She was painfully still as she watched her mother walk up to the stand. Her hand not in mine was clenched into a fist.

Phoebe's mother walked as slowly as possible to that stand. She was still as sickly looking as ever. Nothing had changed since we had last seen her. Her clothes still looked like they were ready to fall off her figure at any moment, and her skin had the same grayish

tint. She makes a point to not look at Phoebe. Not meet her eyes as Phoebe stares her down.

"Mrs. Conners," the judge says. "Do you swear to tell the truth, the whole truth, and nothing but the truth, so help your god?"

"I do," she answers, drawing her hand back from the bible and turning out to the crowd.

"Mrs. Conners," Jonathan's lawyer drawls. I could see a faint shudder come from her as she watched him walk around the courtroom. Her eyes were watching his every moment like a hawk watches its prey. "You are Phoebe and Autumn Conners's mother, correct?"

"I a,," she answers.

"Now, Mrs. Conners, did you ever suspect anything was happening in your home?" Jonathan asks.

She doesn't speak for a moment, looking back and forth between Jonathan and us. She finally meets Phoebe's eyes, tears filling her eyes as she stares down at her daughter.

"I can't say I did ever suspect anything," she answers. "You never suspect the truth."

My heart stops in my chest. I could hear the clicking of cameras and the flashing of lights, but I was looking at Mrs. Conners with a look of pure shock on my face. A smile appears on Phoebe's face as she watches her mother.

"I never had to suspect anything. I knew what you were doing to my girls. I knew just from looking at them. You got bored with me over time, but you couldn't help but see yourself in those girls. You saw parts of yourself, and you couldn't handle that. I didn't do anything about my children, and I live with that regret every day, but I'm not scared of him anymore because you can't hurt me."

This was a side we had never seen in Genevieve. She was crying, holding the necklace that was attached around her to her chest. She turns to look at Jonathan, a look of pure hate filling her eyes.